# THE NO-KILL
# Garden

a collection of
handcrafted plants for the
blackest of thumbs

NIKKI VAN DE CAR and
ANGELA RIO

RUNNING PRESS
PHILADELPHIA

Running Press
Hachette Book Group
1290 Avenue of the Americas, New York, NY 10104
www.runningpress.com
@Running_Press

Printed in China

First Edition: August 2018

Published by Running Press, an imprint of Perseus Books, LLC, a subsidiary
of Hachette Book Group, Inc. The Running Press name and logo is a
trademark of the Hachette Book Group.

The Hachette Speakers Bureau provides a wide range of authors for speaking
events. To find out more, go to www.hachettespeakersbureau.com or call
(866) 376-6591.

The publisher is not responsible for websites (or their content) that are not
owned by the publisher.

Paper craft instructions and photographs by Angela Del Rio.
Prop styling by Kristi Hunter.
Print book cover and interior design by Susan Van Horn.

Library of Congress Control Number: 2018937046

ISBNs: 978-0-7624-6401-2 (paperback), 978-0-7624-6402-9 (ebook)

RRD-S

10  9  8  7  6  5  4  3  2  1

# TABLE OF CONTENTS

# INTRODUCTION

*Many of us love plants . . . but it feels like plants don't love us.
Or we love them to death, with overwatering or underwatering
or maybe we just don't sing to them enough or something. Keeping
a plant alive is a lot harder than it seems like it ought to be,
considering how many of them are flourishing on the other side of
our thresholds. But unlike our pets or our children, plants don't
actively demand the food, water, and attention they require, and in
our busy, distracted lives, it is far too easy to forget about them.*

*This book offers a solution, a way to live the plant-person
lifestyle without all that pesky watering. Even if your thumb is as
black as charcoal, these are plants that you absolutely cannot kill.
Surround yourself with succulents, vines, toadstools, flowers, and
bonsai trees, so that you can admire and love them, but never have to
worry about them. And these aren't just random flowers or leaves—
each of the crafted plants is inspired by a specific variety.*

*Every one of the plants featured here is exceedingly simple to
make. Even if you're a beginning yarn, felt, or paper crafter, you'll
have no trouble creating delightful little plants to bring into your
life / home / cubicle / heart.*

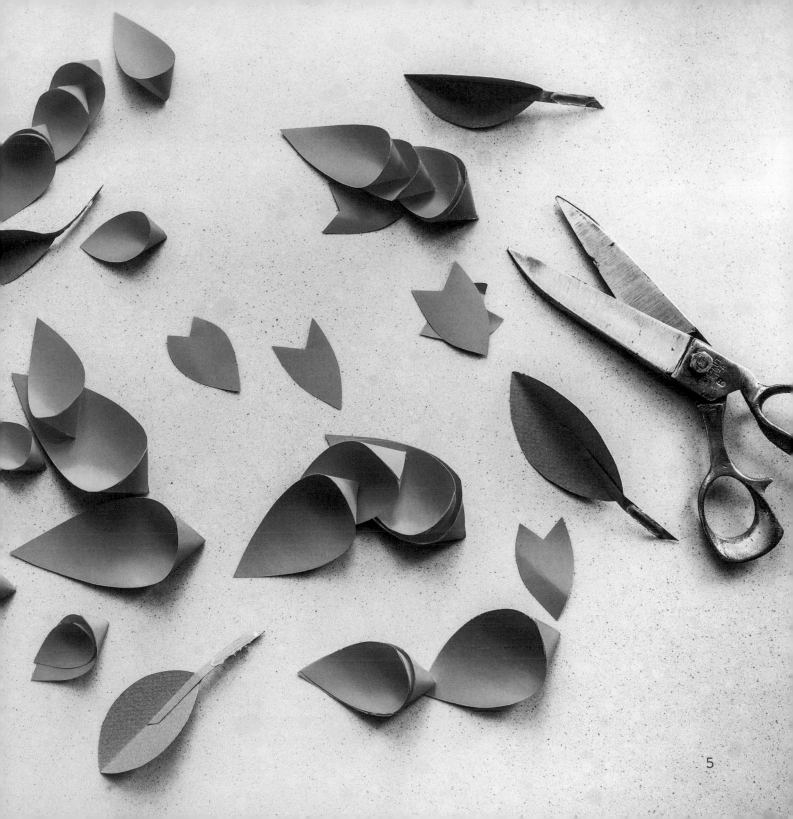

# WOOL VERSUS PAPER
## what kind of plants are these, anyway?

*Plants can be made with anything—fabric, clay, plastics, wood, metals—but the two types of media offered here are paper and wool, simply because they're versatile and easy to work with even for newbie crafters.*

### PAPER

There are three techniques used to create the various paper plants throughout the book: slot joints, folding, and layering. Slot joints are when you create interlocking pieces of paper to form a three-dimensional form, while the folded technique is more like traditional origami—there is little to no cutting, just careful folding along precise lines. Layering involves attaching different-sized pieces of paper atop one another.

### WOOL

You'll find four different approaches to working with wool here: knitting, crochet, needle felting, and felt. You'll need only a very basic understanding of how to knit, crochet, and needle felt, and working with felt just requires the use of a pair of scissors and a needle and thread!

*For quick tutorials on these skills, check out:*

○ **KNITTING:** LoveKnitting.com offers detailed video tutorials.

○ **CROCHET:** TheSpruce.com offers step-by-step instructions, with photos and videos.

○ **NEEDLE FELTING:** NikkiVanDeCar.com explains the basic technique, with photos and videos.

# PERFECT
# IMPERFECTION

As you dive into these projects,
keep one very important thing in mind:

*PERFECTION IS NOT THE GOAL.*

*Plants aren't perfect. Even the loveliest rose has
a petal out of place or a touch of brown.
Leaves aren't evenly spaced on a branch or vine,
and no two leaves look exactly the same. There are
bumps and nubs and splotches and "mistakes."
If your crafted plant is to be as lovable
and authentic as a regular plant,
it must be equally imperfect.*

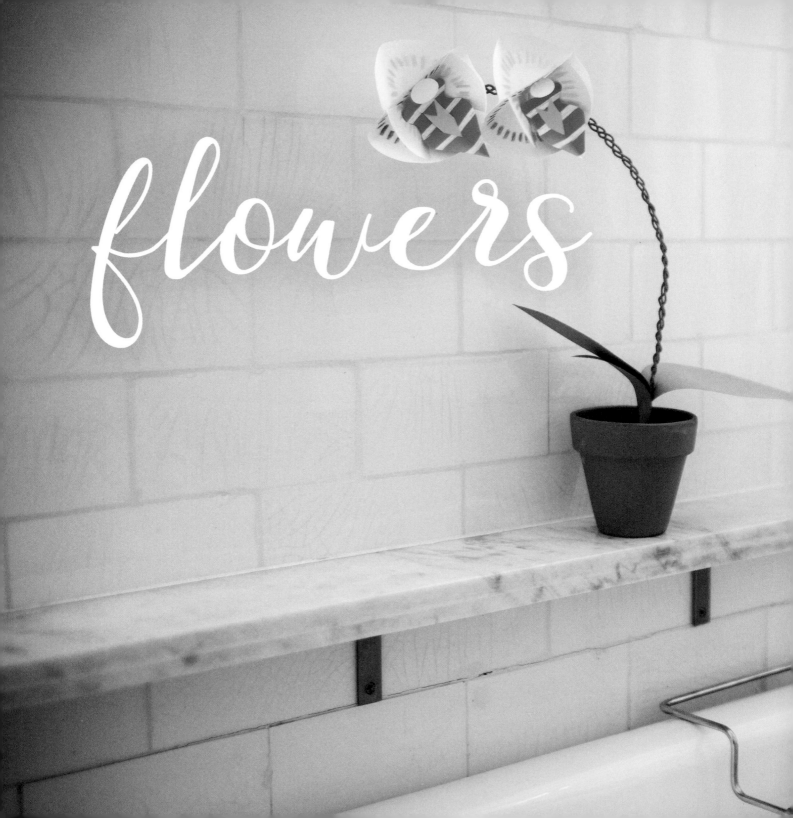

flowers

# orchid

## (PAPER, JOINT)

*Orchids, or Orchidaceae, have more than 28,000 different species—more varieties than there are of birds or bony fishes. They are known for having many structural variations but all keeping a common basal, apex, or axil point. They grow naturally worldwide in tropical forests.*

## MATERIALS

- White paper
- Scissors
- Glue
- Floral wire
- Yellow paper
- Purple paper

## SIZE

*Width of Flower: 3 inches/7.6 cm*

*Height: 12½ inches/31.75 cm*

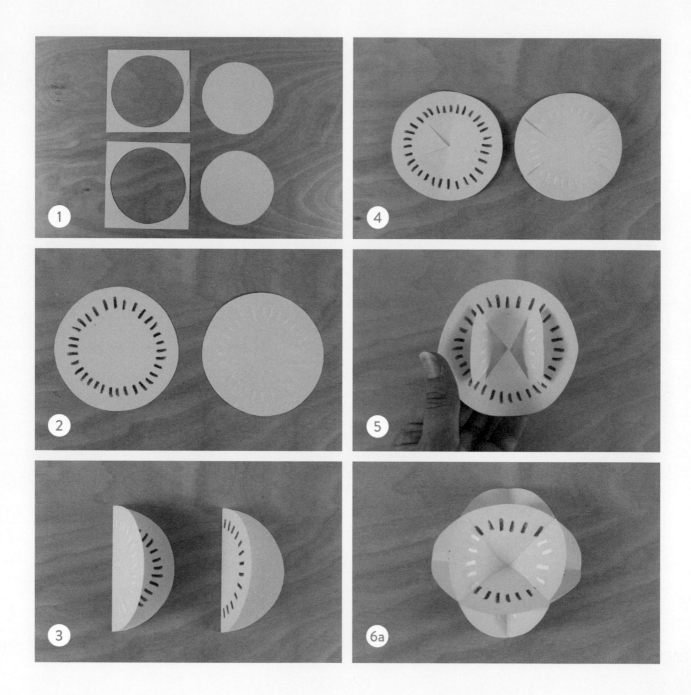

## 1) Cut

Use scissors to cut two identical circles out of white paper.

## 2) Draw

Feel free to draw some decorative dots or stripes to give your flower some detail.

## 3) Fold

Fold one circle in quarters, by first folding in half, then in half again. The second circle should be folded in sixths, by folding in half once, then twice more.

## 4) Cut

To make a slot joint, cut a line just halfway down the center of one circle, and cut the same line halfway down the opposite side of the other circle. When the two pieces combine they lock together. Take the quarter piece and fold it in half to cut a V in the middle of the center fold; when this is unfolded you'll see an X. With the sixth piece, fold the center fold in half and cut the two sides on the circumference of the circle just halfway down, leaving the center fold uncut.

## 5) Combine

Bend the inside flaps of the quarter piece inward and the middle flap of the sixth piece outward toward you. Insert that circle from the back and slide it through until they match each other's edges.

## 6) Fold

Take the quarter piece and fold that uncut valley outward. Take the sixth piece and fold the matching line inward and the perpendicular line on the other piece inward as well. Shimmy until they lock and no longer move.

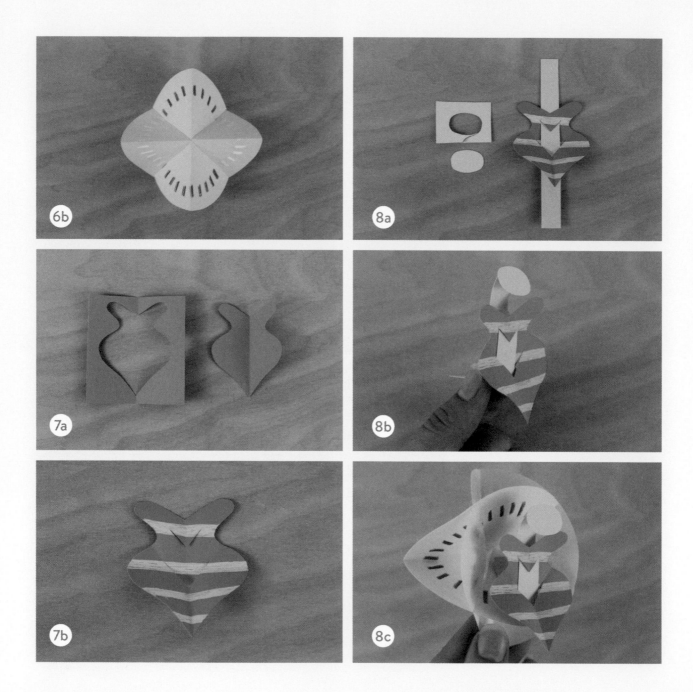

6b

8a

7a

8b

7b

8c

## 7) **Cut**

Use purple paper for the center of the flower and bend it in half to cut out a curvy shape with a pointed bottom. Feel free to draw on it as well. Snip two arrows into the center crease.

## 8) **Cut**

Cut a strip of yellow paper at least 4 inches/10 cm long, just wide enough to slide into the purple piece. Cut a small white oval the width of the yellow strip. Fold the top of the yellow strip and glue the oval. Insert the purple and yellow piece into the cardstock papers so that it pops out of the petals. Glue it in place.

## 9) **Finish**

Cut 3 15-inch/38 cm pieces of floral wire. Braid them together. Use your scissors to poke a hole through the flower and insert the stem from the back.

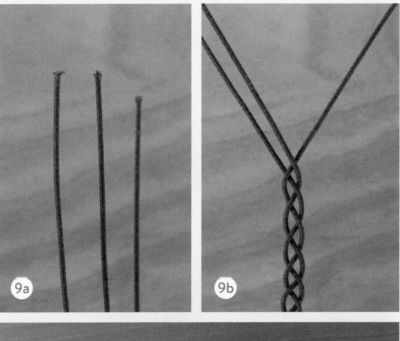

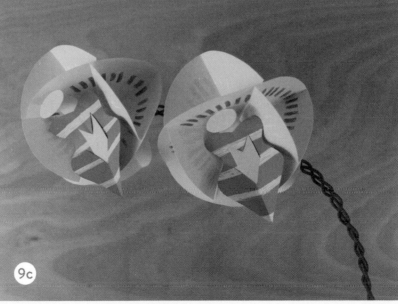

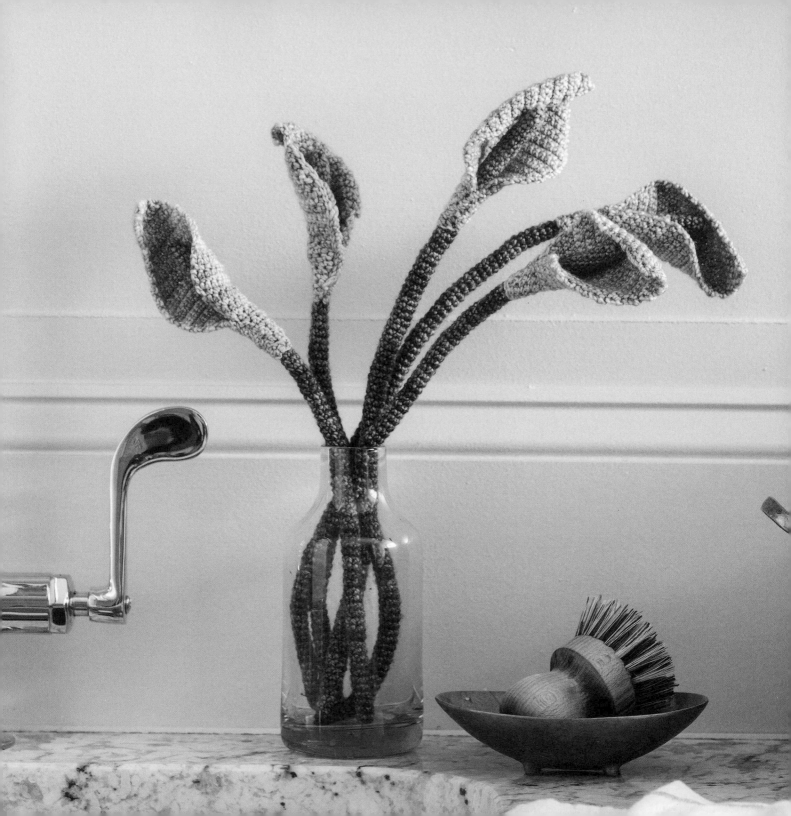

# calla lily

(WOOL, CROCHET)

*Calla lily, arum lily, or Zantedeschia aethiopica, is native to Africa. When in environments with consistent temperatures and rainfall, it behaves like an evergreen, but in more varied climates it behaves like a deciduous plant, losing its leaves and going dormant. It blooms throughout the spring, summer, and fall. Its stems are long, with long pointed leaves at the base, and its flower consists of a spathe and spadix. A spathe is a large bract, which is essentially a type of leaf that looks more like a blossom than an ordinary leaf. A spadix is a firm, elongated cluster of tiny flowers.*

*Calla lilies range in color from white to yellow to pink to a deep, dark purple.*

## MATERIALS

- US B-1/2.25 mm crochet hook
- 60 yards/55 meters fingering weight yarn (shown in Madelinetosh Tosh Sock, in colors MC Calligraphy, CC1 Brick Dust, CC2 Jade)
- Tapestry needle
- Scissors
- Floral wire

## SIZE

*Length of Flower: 15½ inches/39.4 cm*

*Width of Flower: 1 inch/2.5 cm*

### Spathe

**Foundation ch:**
Using MC, ch 7, leaving a 10-inch/25.5 cm tail.

**Row 1:**
Skip first ch, sc in each ch across—6 sts.

**Row 2:**
Ch 1, skip turning ch, sc in each st across.

**Row 3 (inc):**
Ch 1, skip turning ch, work 2 sc in next st, sc in each st to last st, 2 sc in last st—2 sts increased.

**Row 4:**
Ch 1, skip turning ch, sc in each st across.

**Rows 5–16:**
Repeat rows 3 and 4 six more times—20 sts.

**Rows 17–19:**
Ch 1, skip turning ch, sc in each st across.

**Rnds 20–25 (dec):**
Ch 1, skip 2 sts, sc to end—8 sts remain.

**Row 26 (dec):**
Ch 1, skip turning ch, sc2tog, sc to last 2 sts, sc2tog—6 sts remain.

**Row 27 (dec):**
Ch 1, skip turning ch, sc2tog, sc to last 2 sts, sc2tog—4 sts remain.

**Row 28 (dec):**
Ch 1, skip turning ch, (sc2tog) 2 times—2 sts remain.

**Row 29 (dec):**
Ch 1, skip turning ch, sc2tog—1 st remains. Fasten off.

## Spadix

**Foundation ring:**
Using CC1, ch 6, leaving a 10-inch/25.5 cm tail. Join in the rnd with a sl st in first ch to form a ring.

**Next rnd:**
Ch 1, sc in each ch around. Do not join—6 sts.

**Next rnd:**
Work sc in each st around and do not join at end of each rnd.

Repeat last rnd until piece measures 2½ inches/6.5 cm.

**Next rnd:**
(Sc2tog) 3 times—3 sts remain.

**Next rnd:**
Sc3tog—1 st remains. Fasten off. Weave in ends.

## Stem

Attach CC2 to base of spadix with a sl st.

**Next rnd:**
Ch 1, sc in each ch around. Do not join.

**Next rnd:**
Work sc in each st around and do not join at end of each rnd—6 sts.

Repeat last rnd until stem measures 8 to 12 inches/20.5 to 30.5 cm long.

Insert floral wire into the base of the stem, pushing it all the way up to the top of the spadix.

**Next rnd:**
(Sc2tog) 3 times—3 sts remain.

**Next rnd:**
Sc3tog—1 st remains. Fasten off. Weave in ends.

## Finishing

Using CC1 tail from beginning ch threaded through tapestry needle, sew spadix to base of spathe.

Wrap the base of the spathe around the spadix and with MC tail at base of spathe threaded through tapestry needle, sew it in place. Fasten off.

With another piece of MC yarn threaded through tapestry needle, begin at base of spathe and sew the left side of the spathe over the right side, working at a slant for 1 inch/2.5 cm. Do not fasten off.

With yarn still threaded through tapestry needle, work sl st along edge of spathe to the tip, then down remaining edge of spathe to the overlap. Fasten off.

Weave in ends.

# sunflower

## (WOOL, FELT)

*Sunflowers, or Helianthus, are common to North America. They are normally cultivated as decorative plants, but they also grow wild, and are grown for their seeds and their roots, as in the case of the Jerusalem artichoke, which is a variety of sunflower. Sunflowers can grow up to six feet tall, and when they are blossoming, they tilt to face the sun throughout the course of the day. This heliotropism continues until the flower reaches maturity, after which it generally rests facing east. Sunflowers are admired for their symmetry as well as their size—they display both the Fibonacci sequence and the Golden Angle.*

## MATERIALS

o 2 8½ × 11-inch/22 × 28 cm sheets of brown felt

o 2 8½ × 11-inch/22 × 28 cm sheets of light yellow felt

o 2 8½ × 11-inch/22 × 28 cm sheets of dark yellow felt

o 2 4-inch/10 cm Popsicle sticks

o 1 .1875/5 mm × 12-inch/30 cm dowel rod

o Craft glue

o Scissors

o Needle & brown thread

## SIZE

*Length of Flower: 10¾ inches/27.3 cm*

*Width of Flower: 11¼ inches/28.6 cm*

*Height: 15½ inches/39.4 cm*

## Pattern

Form an X out of two Popsicle sticks and glue them together. Lay the dowel atop that X and glue it in place. Together, they should form a star, with the length of the dowel reaching down like a stem.

Cut 2 6-inch/15 cm diameter circles out of the brown felt.

Cut 6 petals out of the light yellow felt, 3½ inches/9 cm long, 2½ inches/6.5 cm wide at the bottom, and tapered into a point at the top.

Cut 6 petals out of the light yellow felt, 3 inches/7.5 cm long, 2 inches/5 cm wide at the bottom, and tapered into a point at the top.

Lay the smaller petals atop one of the brown circles, pointing *inward*, with the wide bottoms arcing around the edge of the circle. Pin the petals in place, and stitch them to the circle.

Lay the larger petals atop the smaller petals, again pointing inward, placing them so that they lie between the smaller petals. Pin them in place, and stitch them to the circle.

Place the brown circle with the petals atop the plain brown circle, with the petals facing you. Flip the petals over so they look more like a sunflower. Stitch the flower to the plain brown circle, sewing just inside the line of petals. Sew around, leaving a gap large enough to insert the Popsicle stick star. Don't cut thread.

Insert the Popsicle stick star, leaving the dowel sticking out. Continue to sew, until the star doesn't fall out, leaving about 2 inches/5 cm.

Stuff the flower, over the Popsicle star, then stitch the gap closed around the dowel.

Place a small dab of glue on the back of each petal and press it to the brown circle behind it, to make sure the petals stay upright.

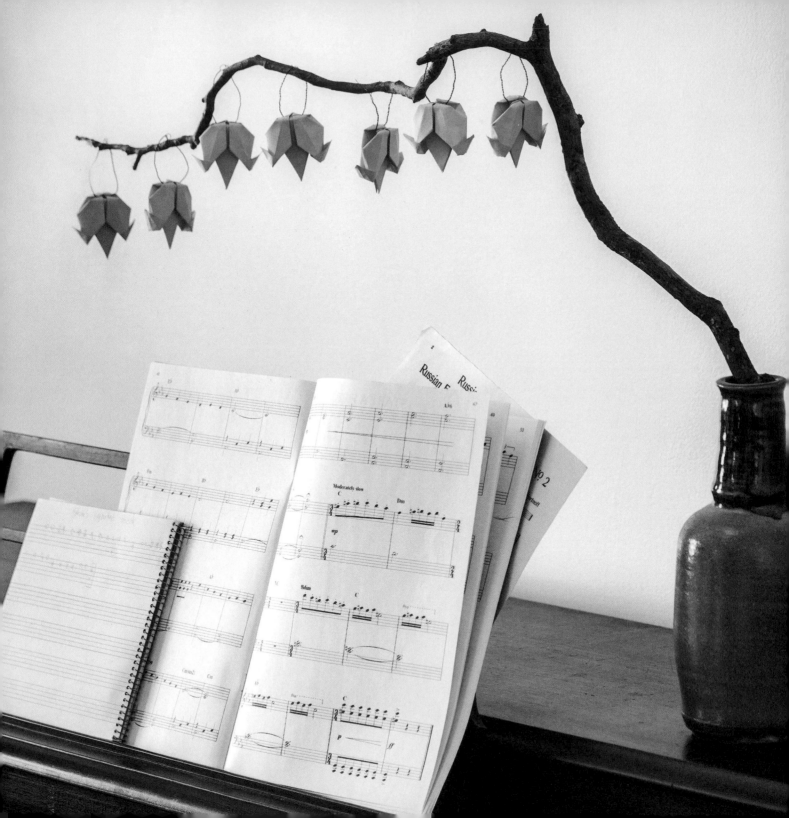

# bleeding heart

(PAPER, FOLD)

*The most common type of bleeding heart is Dicentra spectabilis—also known as "old-fashioned bleeding heart." As the name suggests, the flowers are heart-shaped, with what looks like a little drop of blood hanging from the bottom. As with roses, different colors of bleeding hearts have different symbolic meanings: pink and red are for romantic love, and white bleeding hearts represent purity.*

## MATERIALS

○ Pink paper

○ Scissors

○ Floral wire

○ Tree branch

## SIZE

*Length of Flower: 2¼ inches/5.7 cm*

*Width of Flower: 2¼ inches/5.7 cm*

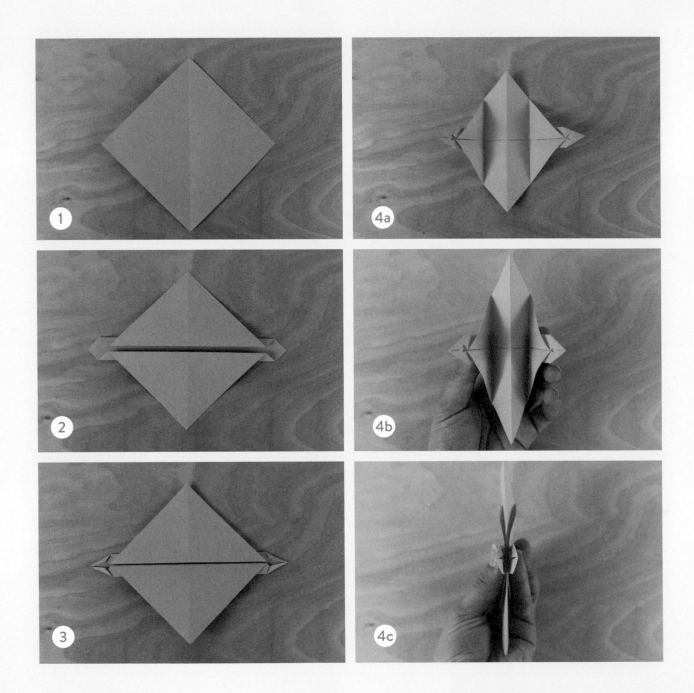

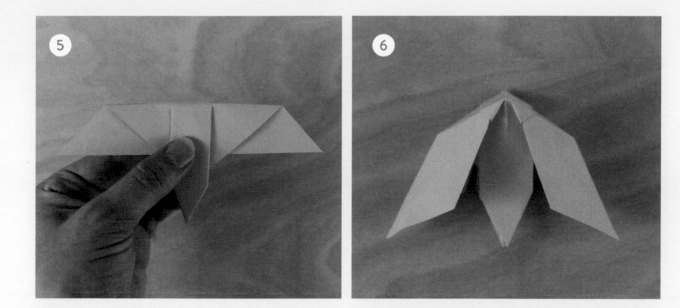

**1) Cut**

For small flowers, cut a 5-inch/12.5 cm square piece of paper.

**Fold**

Fold the paper in half.

**2) Fold**

Fold the opposite edge approximately ½ inch/1.5 cm from the center on both sides. Then fold again outward, creating a fold ¼ inch/.75 cm from the middle on both sides.

**3) Fold**

Bend the edges of the points you just created inward to make a sharper arrow.

**4) Fold**

Fold two more creases 1 inch/ 2.5 cm from the center line you created in the beginning. Then squeeze the middle crease downward so that the whole piece becomes flat.

**5) Flip**

Turn the orientation of the piece 90 degrees so that the arrow is facing south.

**6) Fold**

Fold the top points symmetrically downward.

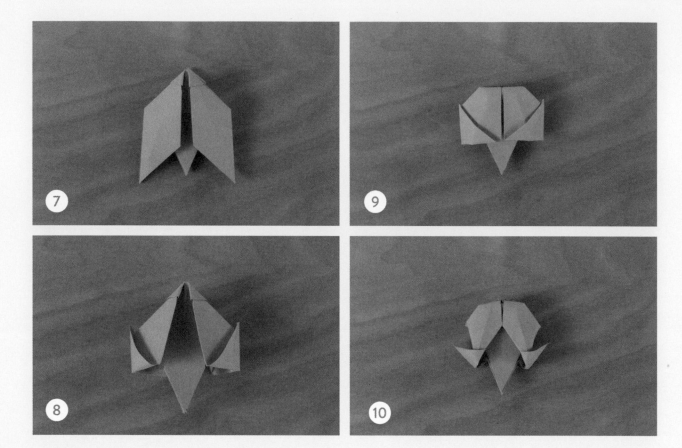

7) **Fold**

Open those points and bring them down, so that they can point south and not east to west. Add some creases at the top to make it a clean fold.

8) **Fold**

Open those points up to mimic the bleeding heart opening up and revealing the inside.

9) **Fold**

To mimic the flower's heart-shaped top, hide the point at the top by folding it into the center.

10) **Fold**

Pinch the sides inward, to create a tapered look.

11) **Finish**

Make multiple origami bleeding hearts, and use floral wire to attach them onto a naturally fallen tree branch.

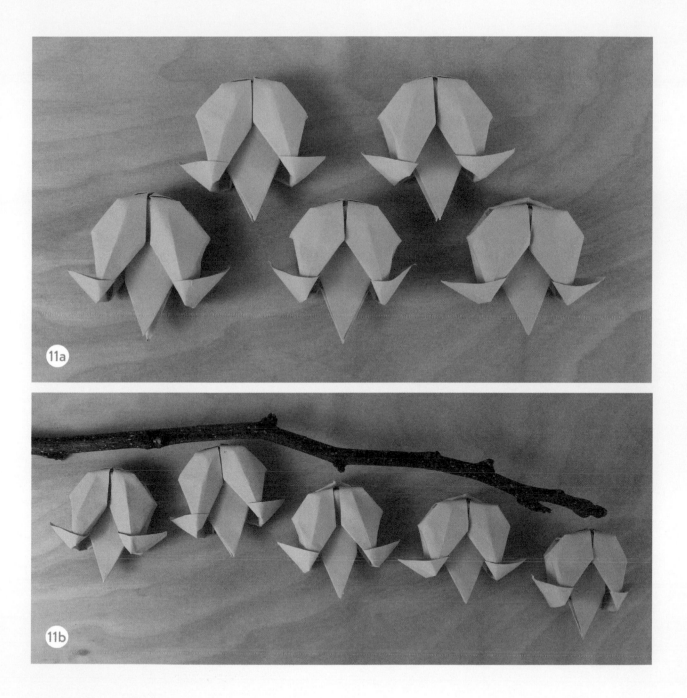

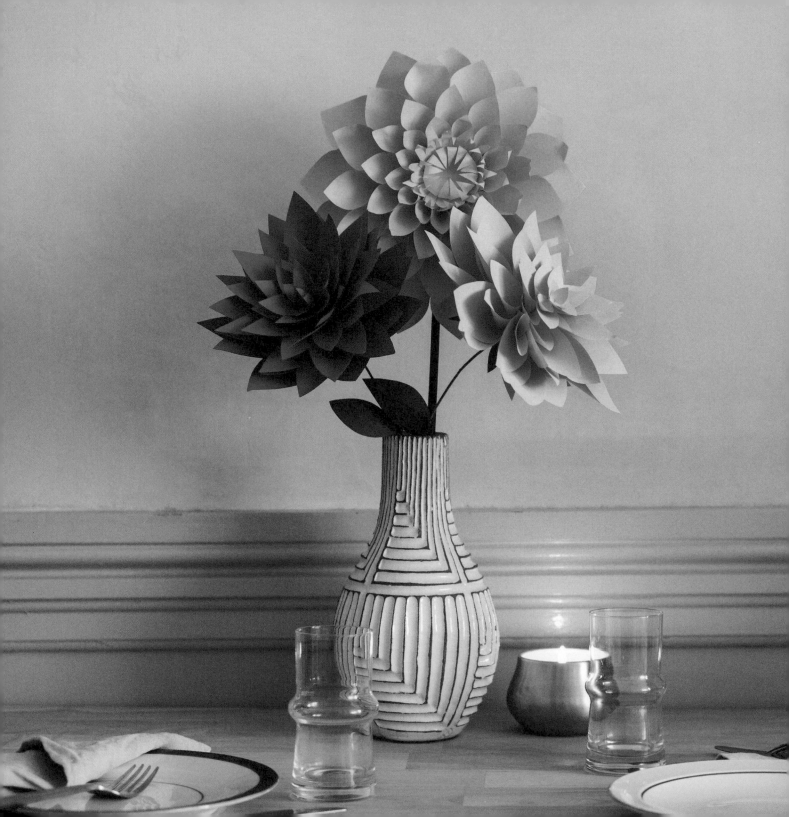

# dahlia

(PAPER, LAYER)

*Dahlias range in size from 2 inches to up to 12 inches in diameter. This wide range is because dahlias are octoploids—meaning they have eight chromosomes, while most plants have only two. While a dahlia looks like one big flower, in fact each petal is actually a floret  a flower in its own right. Dahlias symbolize gratitude and dignity.*

## MATERIALS

- Lightweight yellow paper
- Scissors or X-Acto
- Pencil
- Hot glue
- Cardboard
- Dowel
- Green paint

## SIZE

**Orange/Pink Flowers**

*Length: 6½ inches/16.5 cm*

*Width: 6½ inches/16.5 cm*

*Height: 13¾ inches/32.4 cm*

**Yellow Flower**

*Length: 8½ inches/21.6 cm*

*Width: 8¼ inches/21 cm*

*Height: 19½ inches/49.5 cm*

## 1) Mark

To make multiple petals of the same size, trace a template for each of the four variations pictured. Each should be shorter in height by ½ inch/1.5 cm.

## Cut

Cut 15 of each of the four sizes of petals out of the lightweight yellow paper. Cut a 3-inch/.75 cm circle out of cardboard for the base.

## 2) Bend

Take the bottom corners and curl them inward with one side overlapping the other.

## Adhere

Apply some hot glue to keep the curl together for each petal. Do this for all four petal sizes.

## 3) Adhere

Glue the biggest petals onto the cardboard base. Line them up next to each other, one by one, as you fill up the outer edge.

## Layer

Glue down the second batch of petals, applying them in a staggered 50/50 offset pattern so that the new petal is in between two big petals and further toward the center. The third and fourth batch of petals should be glued down in the same manner, so that the shapes become smaller and more concentrated as they get closer to the center.

## 4) Cut

Cut 3 squares of paper that are big enough to cover the exposed area of the cardboard base but fit inside the smallest row of petals. Cut them in a starburst shape with curved tips.

## 5) Bend

To mimic the blossoming center of the dahlia, curl the ends of the pieces you just cut to gradually lean inward. Curl one of the 3 pieces so that the tips almost touch the center of the paper. Glue them atop one another, offsetting them.

## 6) Attach

Glue that center piece onto the layered petals you just arranged.

## Finish

You can keep the flower as it is and mount it on a wall, or attach a green dowel to the back, add a few leaves, and have the finished dahlia on a stem.

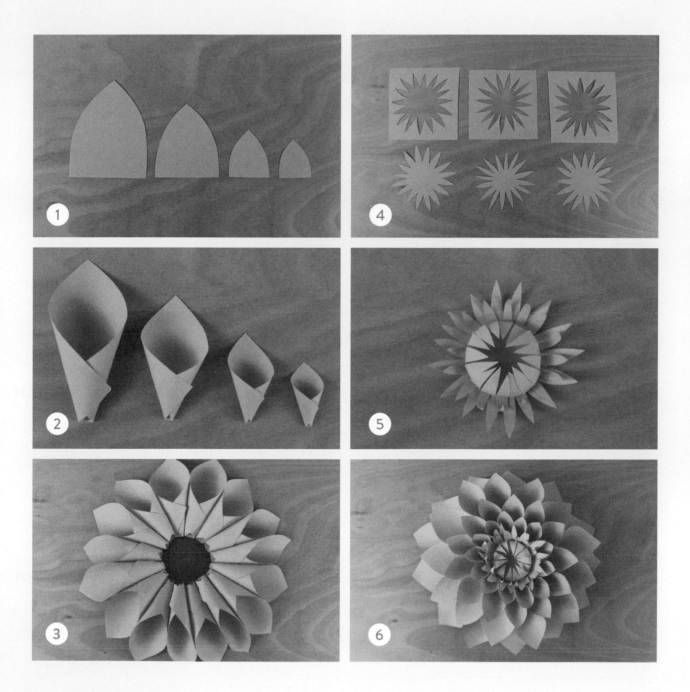

# rose

(WOOL, FELT)

*The popular rose, or rosa, is a woody perennial, and comes in thousands of varieties. Some are known for their scent, others for hardiness—or for their thorns. They are so beloved that many cultivated individual varieties have been given names, like "Great Maiden's Blush." These names are for varieties that have been cultivated recently, or in the case of heirlooms, hundreds or even thousands of years ago.*

## MATERIALS

- 1 8½ × 11-inch/22 × 28 cm sheet of light pink felt (makes 4–5 flowers)
- 1 8½ × 11-inch/22 × 28 cm sheet of medium pink felt (makes 4–5 flowers)
- 1 8½ × 11-inch/22 × 28 cm sheet of dark pink felt (makes 4–5 flowers)
- 1 8½ × 11-inch/22 × 28 cm sheet of green felt (makes 7–10 flowers)
- Scissors
- Needle & thread
- Small stick or twig (optional)
- Fishing line (optional)
- 34 crystal beads (optional)

## Rose Pattern

Using the picture of the shapes as a guide, cut similar pieces of felt, varying the shades of pink as desired. It doesn't have to be exact. From smallest to largest, the sizes shown are:

1¾ × ¾ inches/4.5 × 2 cm

2 x 1 inches/5 × 2.5 cm

2¾ x 1 inches/7 × 2.5 cm

2¾ x 2½ inches/7 × 6.5 cm

2½ x 3 inches/6.5 × 7.5 cm

3 x 3½ inches/7.5 × 9 cm

The green stem is 1¼ × 1¼ inches/3 × 3 cm, measured from the points. You can cut your pieces to these measurements, or make larger or smaller roses, as you prefer.

Starting with the smallest pink rose piece, roll it into a tube and stitch the tube in place at one end with your needle and thread. Layer the larger pieces, rolling them and stitching them as you go. Curl the curved rose pieces around your tube, stitching them as you go.

Stitch the green stem onto the back of your rose.

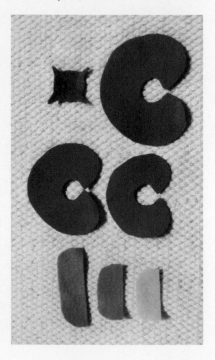

## Assemble Mobile

To make a mobile like the one shown, you will need 20 roses. Cut a 36-inch/91 cm length of fishing line. Tie a knot at one end and thread your needle at the other.

**STEP 1:** Insert your needle into the center front of a rose and draw through to the knot, pulling tight.

**STEP 2:** Insert needle through a bead, slide to 1 inch/2.5 cm above the rose, and insert needle through the bead once more.

**STEP 3:** Insert needle through a second bead, slide to 1 inch/2.5 cm above first bead, and insert needle through this second bead once more.

**STEP 4:** Tie a knot 1 inch/2.5 cm above the second bead. Insert needle through one side of the green stem to the other side of the green stem.

**STEPS 5–13:** Repeat Steps 2–4 three times. Cut fishing line, leaving a 6-inch/15 cm tail.

Make a second string of roses as above, and make a third, longer string, repeating Steps 2–4 four times instead of three.

Tie the strands to the twig, shorter ones on the outside, longest one on the inside. Tie a strand of fishing line to each end of the twig to serve as a hanger. Trim any bits of fishing line that are sticking out.

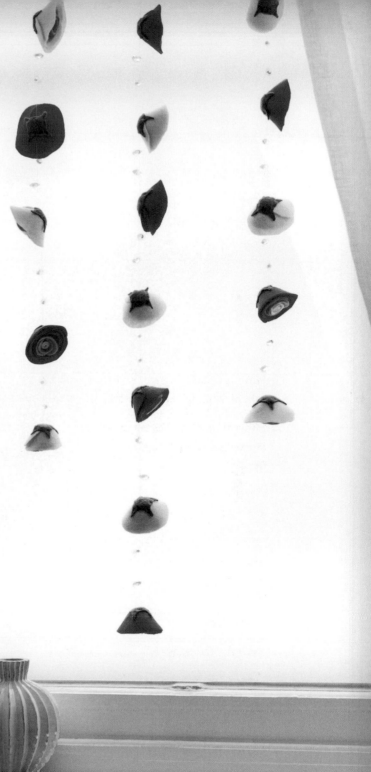

# hydrangea
(WOOL, CROCHET)

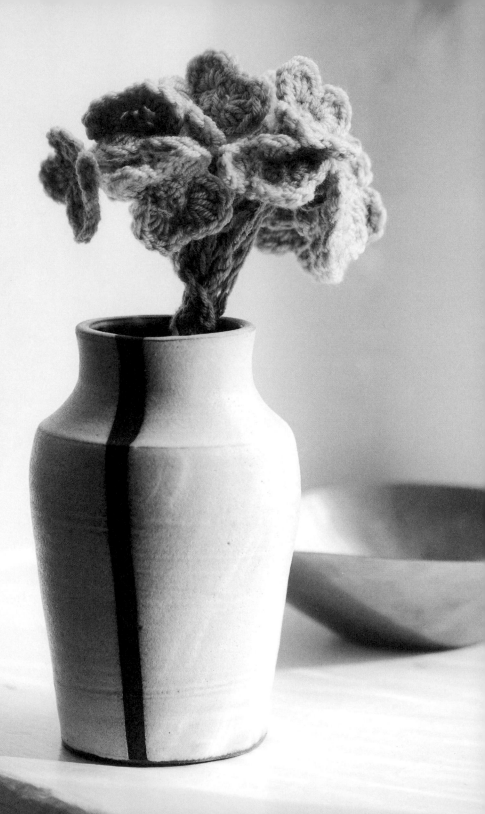

Hydrangea, or Hydrangea
Macrophylla, feature bouquets
of small clusters of flowers.
They thrive in moist, fertile,
well-drained soil, in partial to
full shade. They come in a
number of varieties, including
lacecap, with tiny buds and
scattered flowers, and the ball of
flowers shown here. They
also come in a variety of colors,
including shades of blue, pink,
yellow, and white. The change in
the flower color often results
from a lower pH and a higher
aluminum content in the soil.
Prune them often to produce
more flowers.

## MATERIALS

- US E-4/3.5 mm crochet hook
- 100 yards/91 meters fingering weight yarn (MC, shown in Malabrigo Mechita, in color Pegaso)
- 50 yards/46 meters DK weight yarn (CC, shown in Madelinetosh Tosh DK, in color Lettuce Leaf)
- Tapestry needle
- Scissors
- Floral wire
- 16 seed beads

## SIZE

*Length of Flower: 8 inches/20.3 cm*

*Width of Flower: 1½ inches/3.8 cm*

### Flowers (make 16)

**Foundation ring:**
With MC, ch 3. Join in the rnd with a sl st in first ch to form a ring.

**Rnd 1:**
Ch 1, work 7 sc around ring, join with a sl st in top of first sc—7 sts.

**Rnd 2:**
Ch 3, *skip 1 st, sc in next st, ch 2; repeat from * 3 more times, sl st in the base of the beginning ch—4 sc and 4 ch-sps.

**Rnd 3:**
Ch 1, (sc, hdc, 3 dc, hdc, sc) in each ch-sp around, sl st in base of beginning ch—28 sts.

Turn flower over and sl st down the back to the foundation ring, pulling a little to make the flower pucker. Fasten off.

Attach CC on back side of flower, at the base of the foundation ring. Make a ch 8 inches/20.5 cm long. Fasten off.

Weave in ends.

### Adding Wire

Insert floral wire into the center of the flower and thread it all the way down to the bottom of the stem. Curve it up and tuck the end into the stem. Clip the wire near the flower and thread a seed bead onto it, tucking the end of the wire into the seed bead. Repeat for the remaining 15 flowers.

### Making Bouquet

Arrange the flowers 2 or 3 at a time, fanning them out into a bouquet and twisting their stems together.

# daisy

(PAPER, LAYER)

*There are over 2,800 species of daisies, from the Devil's River daisy to the seaside daisy, the marguerite daisy, and the crown daisy. Because of this, daisies are filled with symbolism, from several different mythologies. In Celtic lore, it is said that whenever an infant dies, God sprinkles daisies over the land to console the bereaved parents, but in Norse mythology daisies are tied together with childbirth, fertility, and new beginnings. In Old English, daisies were referred to as "Day's Eye," since the white petals close around the yellow centers at night, and open in the mornings.*

## MATERIALS

- Yellow cardstock
- White paper
- Scissors or X-Acto
- 1-inch hole punch (optional)
- 2½-inch hole punch (optional)
- Glue
- Hot glue
- Green embroidery floss or string
- Embroidery needle
- Balsa wood
- Awl

## SIZE

*Length of Flower: 2½ inches/6.4 cm*

*Width of Flower: 2½ inches/6.4 cm*

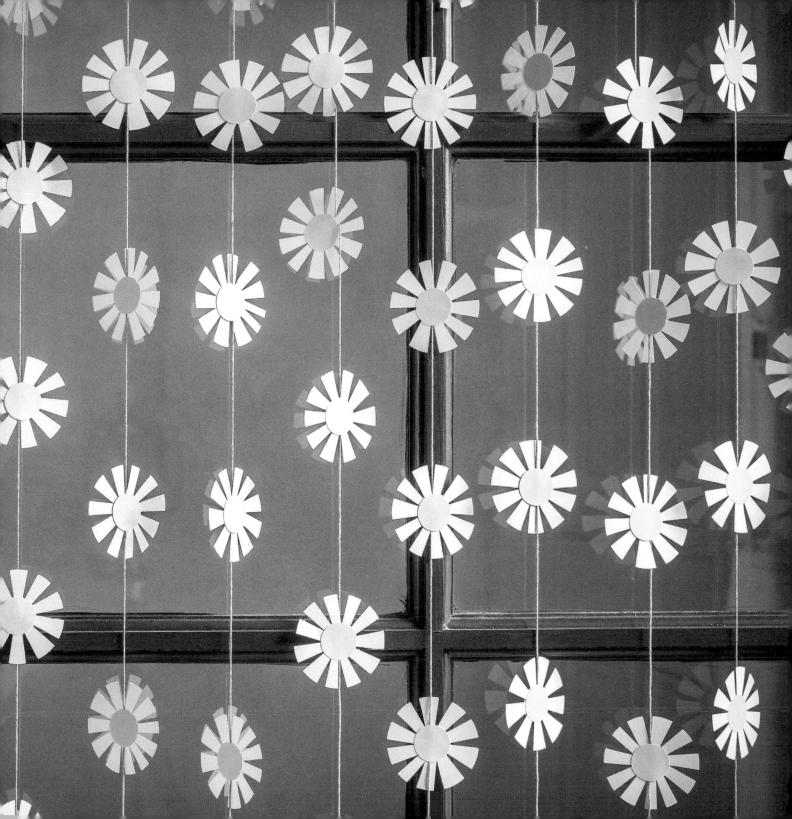

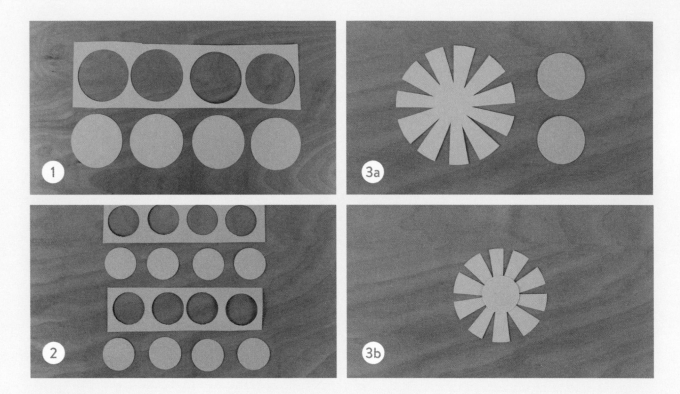

1) **Cut**

Use scissors to cut strips of white paper at least ¼ × 2½ inches / ½ × 6½ cm. Cut 2½-inch/6.5 cm diameter circles with either the hole punch or a scissors/X-Acto blade. You'll need at least 100 circles to cover a doorway as pictured.

2) **Cut**

Use the same method to cut out 1-inch/2.5 cm diameter yellow circles. These will become the center of the flower and they will cover the front and back of each white circle, so cut twice as many yellow circles as white circles.

3) **Cut**

Cut out the details for each petal from the white circles. They don't need to be perfect!

4) **Measure**

The lengths of the embroidery floss/string and the piece of balsa wood holding all of the daisies together depend on the size of the doorway you want to hang the daisies in. You can divide the width of the doorway by three and that will give you the number of strings you need. The length of the strings will be the length of your door minus 1 foot/30 cm.

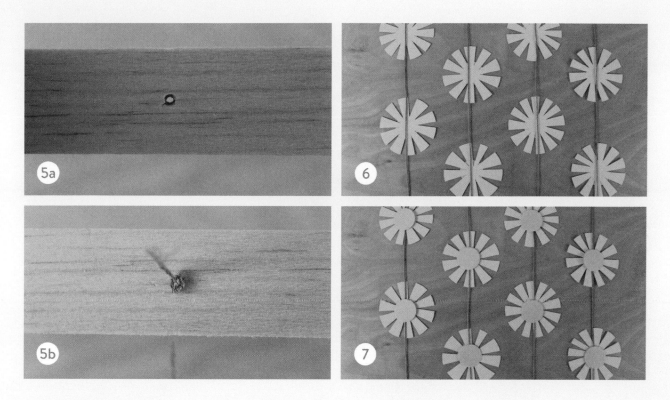

### 5) Assemble

Use the awl to poke small holes through the balsa wood, spaced 3 inches/7.5 cm apart. Thread the embroidery floss through the holes and tie a knot. It might be necessary to double or triple knot it so that it doesn't fall through when the string gets tugged. When you nail the piece to the top of your doorway, you may notice that the embroidery floss has kinks in it from being bundled. If that's the case, you can moisten each piece with water so that it can dry straight as it hangs.

### 6) Adhere

Glue the yellow circles onto one side of each cut-out daisy.

### 7) Adhere

Apply hot glue to the center of the blank-sided daisy and place it behind the string while attaching the last yellow circle. Hold it in place as the glue dries. Continue attaching the daisies to the embroidery floss in a 50/50 offset pattern (like polka dots) all the way down and across.

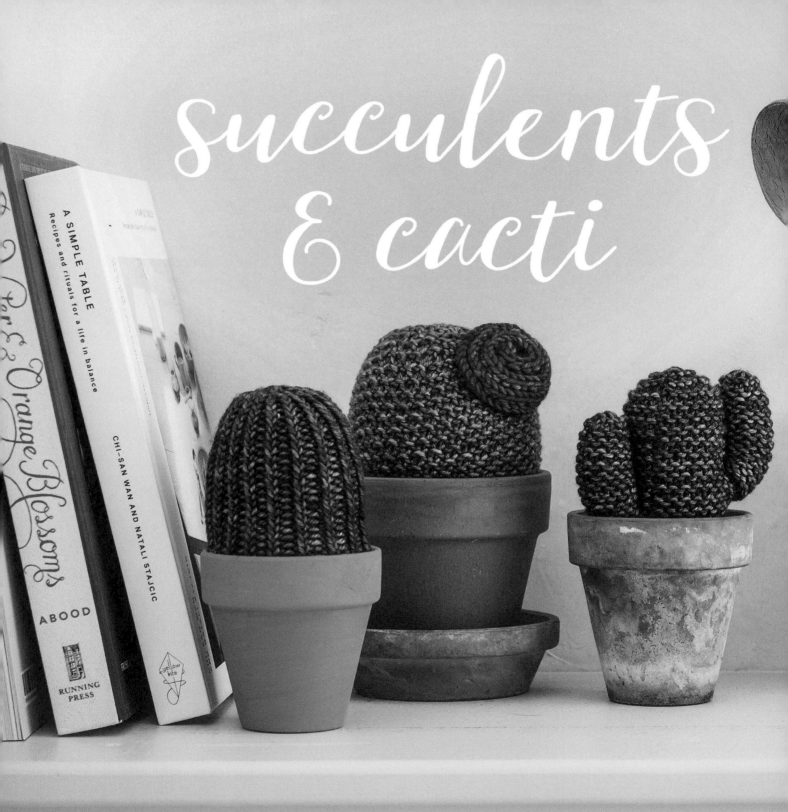

succulents
& cacti

# potted cacti

(WOOL, KNIT)

*Notocactus, specifically here Notocactus graessneri flaviflorus, are globulous, frequently solitary cacti with evenly placed, diamond-patterned spikes. They can often appear quite hairy. They produce bell-shaped flowers in pink or yellow, and are native to drier parts of Brazil and Uruguay.*

*Cereus is a very loose genus of cacti, including any types that are large, columnar, and vertically ridged. It is a group defined mostly by meeting these characteristics, and not really belonging anywhere else.*

*The saguaro, a tree-like cactus, is one of the iconic and defining plants of the Sonoran desert. They frequently develop arms as they age, and under the right conditions, they can live up to 200 years.*

## MATERIALS

- US 5/3.75 mm set of 5 double-pointed needles

- US 5/3.75 mm straight needles

- 200 yards/183 meters worsted weight yarn (shown in Madelinetosh Tosh Vintage, in colors Fir Wreath and Cactus Flower, and Malabrigo Rios, in color Fresco y Seco)

- Tapestry needle

- Scissors

- Small clay pots, 4 inches/10 cm high, and with a mouth no wider than 4¾ inches/12 cm for the Notocactus, and 3 inches/7.5 cm high, with a mouth no wider than 3 inches/7.5 cm, for the other specimens

- Fiberfill stuffing

- Hot glue gun

## SIZE

**Notocactus**

*Length: 4 inches/10.2 cm*

*Width: 4 inches/10.2 cm*

*Height: 4 inches/10.2 cm*

**Cereus**

*Length: 2 inches/ 5.1 cm*

*Width: 2 inches/5.1 cm*

*Height: 3 inches/7.6 cm*

**Saguaro**

*Length: 1½ inches/3.8 cm*

*Width: 4 inches/10.2 cm*

*Height: 6 inches/15.2 cm*

## *NOTOCACTUS*

With dpn, cast on 44 sts.

Divide sts evenly over 4 dpn, with 11 sts on each needle. Pm and join to work in the rnd, taking care not to twist sts.

**Rnd 1:**
*K1, p1; repeat from * to end of rnd.

**Rnd 2:**
*P1, k1; repeat from * to end of rnd.

Repeat rnds 1 and 2 for 3 inches/ 7.5 cm, ending with rnd 1.

**Shape top**

**Rnd 1 (dec):**
*P1, k1, p2tog; repeat from * to end of rnd—33 sts remain.

**Rnd 2 (dec):**
*K1, p2tog; repeat from * to end of rnd—22 sts remain.

**Rnd 3:**
*P1, k1; repeat from * to end of rnd.

**Rnd 4:**
*K1, p1; repeat from * to end of rnd.

### Rnd 5 (dec):

*P2tog, k2tog; repeat from * to last 2 sts, p2tog—11 sts remain.

### Rnd 6:

*K1, p1; repeat from * to last st, k1.

Break yarn, leaving an 8-inch/ 20.5 cm tail. Thread the tail into tapestry needle and draw through the remaining stitches, pulling tight to close the hole. Weave in ends.

### Flower

With pink or yellow worsted weight yarn and straight needles, cast on 25 sts.

### Row 1:

Knit.

### Row 2 (inc):

*K1, M1; repeat from * to last st, k1—49 sts.

### Row 3:

Knit.

### Row 4 (inc):

*K1, M1; repeat from * to last st, k1—97 sts.

### Row 5:

Knit.

Bind off all sts. Break yarn, leaving a 20-inch/51 cm tail.

Wind the flower into a spiral (it will want you to). Using the tail from the bind-off edge, sew the cast-on edge together into the spiral shape. Leave the remainder of the tail—don't cut it.

### Finishing

Stuff the larger clay pot. Stuff the cactus fairly firmly, and set aside. Press a 2-inch/5 cm line of hot glue along the inside rim of the clay pot, and press the cactus against the line of glue. Continue gluing in this manner until the cactus is attached completely to the clay pot.

Using remaining tails of the flower, sew the flower to the top of the cactus at a jaunty angle.

## CEREUS CACTUS

With dpn, cast on 36 sts. Divide sts evenly over 3 dpn with 12 sts on each needle. Pm and join to work in the rnd, taking care not to twist sts.

### Rnd 1:

*K1tbl, p1, repeat from * around.

Rep rnd 1 until piece measures 4 inches/10 cm.

### Shape top

### Dec rnd 1:

*K1tbl, p1, ssk; repeat from * around—27 sts remain.

### Dec rnd 2:

*Ssk, k1tbl; repeat from * around—18 sts remain.

### Dec rnd 3:

*Ssk; repeat from * around—9 sts remain.

Break yarn, leaving an 8-inch/ 20.5 cm tail. Thread the tail into tapestry needle and draw through remaining sts, pulling tight to close the hole. Weave in ends.

### Finishing

Stuff one of the smaller clay pots. Stuff the cactus fairly firmly, and set aside. Press a 2-inch/5 cm line of hot glue along the inside rim of the clay pot, and press the cactus against the line of glue. Continue gluing in this manner until the cactus is attached completely to the clay pot.

## SAGUARO CACTUS

With dpn, cast on 24 sts. Divide sts evenly over 4 dpn, with 6 sts on each needle. Pm and join to work in the rnd, taking care not to twist sts.

**Rnd 1:**
Knit.

**Rnd 2:**
Purl.

Repeat rnds 1 and 2 until piece measures 5½ inches/14 cm, ending with a purl rnd.

**Shape top**

**Dec rnd 1:**
*K2, k2tog; repeat from * around—16 sts remain.

**Dec rnd 2:**
*P1, p2tog; repeat from * around—8 sts remain.

**Dec rnd 3:**
*K2tog; repeat from * around—4 sts remain.

Break yarn, leaving an 8-inch/20.5 cm tail. Thread the tail into tapestry needle and draw through remaining sts, pulling tight to close the hole. Weave in ends.

**Arms (make 2)**

With dpn, cast on 12 sts, leaving a 10-inch/25.5 cm tail. Divide sts evenly over 3 dpn, with 4 sts on each needle. Pm and join to work in the rnd, taking care not to twist sts.

**Rnd 1:**
Knit.

**Rnd 2:**
Purl.

Repeat rnds 1 and 2 until piece measures 2½ inches/6.5 cm, ending with a purl rnd.

**Dec rnd:**
*K1, k2tog; repeat from * around—6 sts remain.

Break yarn, leaving an 8-inch/20.5 cm tail. Thread the tail into tapestry needle and draw through remaining sts, pulling tight to close the hole. Weave in this tail, but leave the cast-on tail hanging.

Stuff the arms. Using the cast-on tail, sew the arms to opposite sides of the body as pictured. Weave in cast-on tails.

Stuff the body. Insert a separate strand of yarn into the top of one arm, bending that arm up and sewing it to the body, so that it stands up. Weave in these ends, and repeat with the other arm.

Stuff the remaining smaller clay pot. Press a 2-inch/5 cm line of hot glue along the inside rim of the clay pot, and press the cactus against the line of glue. Continue gluing in this manner until the cactus is attached completely to the clay pot.

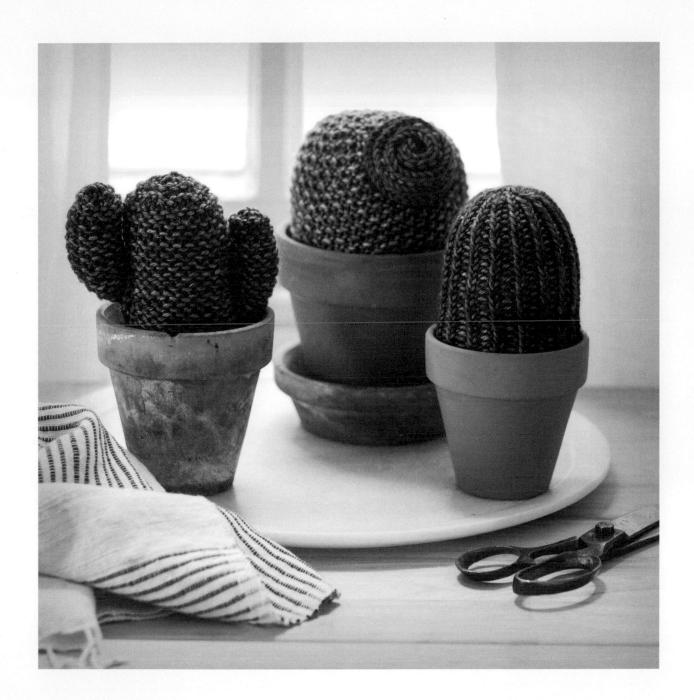

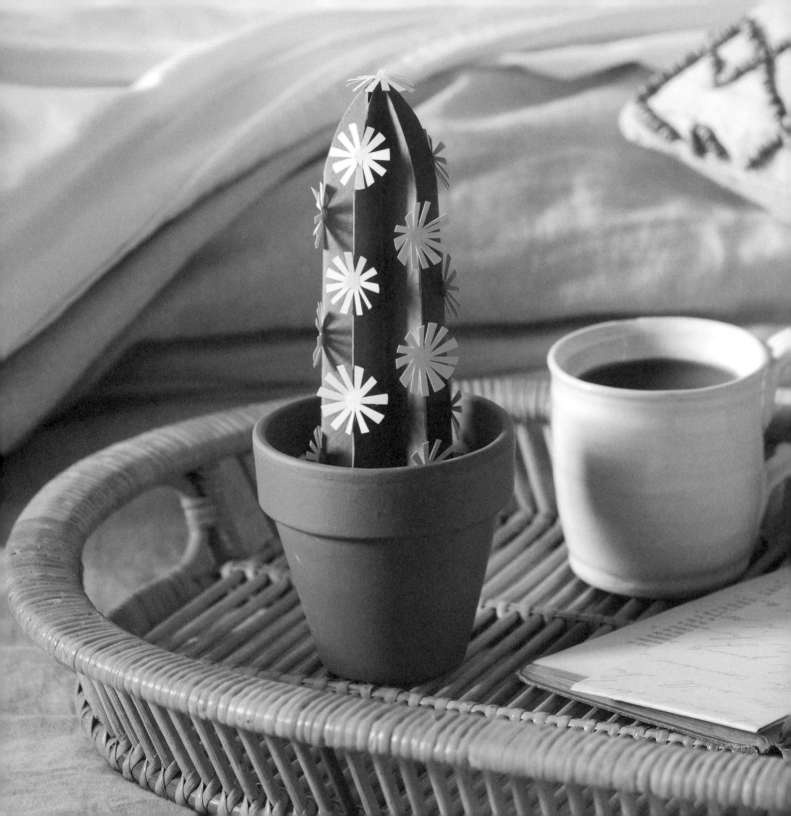

# torpedo

**(PAPER, FOLD)**

*The torpedo cactus stands tall and straight, and while it may not be a weapon, its spines are sharp and can be quite dangerous. Small white flowers bloom at night, attracting bats and sphinx moths.*

## MATERIALS

○ Green cardstock

○ Yellow cardstock

○ Scissors or X-Acto

○ 1-inch hole punch (optional)

○ Hot glue

## SIZE

*Length: 3 inches/7.6 cm*

*Width: 3 inches/7.6 cm*

*Height: 7½ inches/19 cm*

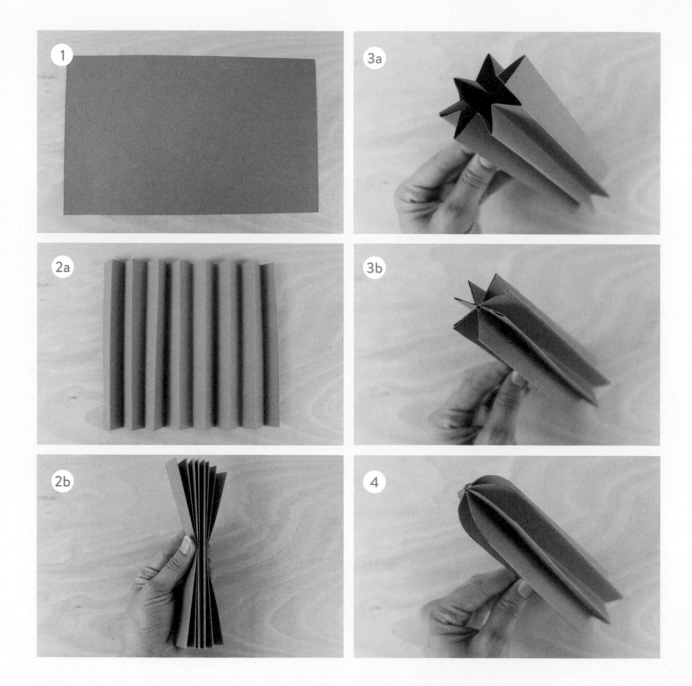

### 1) Cut

Use scissors to cut green cardstock at least 14 inches/ 36 cm wide and 7 inches/18 cm tall, or however tall you want your cactus to be.

### 2) Fold

Create an even accordion fold along the longest side (landscape). You could fold the paper back and forth at a consistent width or you could fold the piece in half, then each half in half, and continue until you have 7 mountains. Each panel should be between ½ inch/1.25 cm and 1 inch/2.5 cm wide.

### 3) Adhere

Apply hot glue to the inside of each mountain fold. Hold the two planes together until the glue dries. Repeat this until all folds are glued together. At this point, the beginning of the accordion fold should meet the end. Hot glue the ends together so they form a cylinder.

### 4) Cut

Round the top of the torpedo by cutting off the corners of the glued folds, curving them.

### 5) Cut

Use a 1-inch hole punch or hand-cut 4 yellow circles for each spine. Cut the circles so that they resemble spikes. Make enough to cover the spines of the torpedo folds evenly.

### 6) Adhere

Place each spike piece onto the spines of the cactus with a tiny dab of hot glue.

### Finish

Stick it into a terra-cotta pot with some brown paper to mimic sand, and never ever give it water!

# compton carousel

## (PAPER, LAYER)

*The Compton Carousel is a rare type of Echeveria, with short blue-gray leaves with creamy margins. They have small, cream-colored shoots of smaller rosettes, though these often die off, as Compton Carousel is a little fussier than your typical Echeveria.*

### MATERIALS

- Light-green paper
- Green pencil
- Scissors or X-Acto
- Hot glue
- Cardboard

### SIZE

*Length: 3¼ inches/8.3 cm*

*Width: 3¼ inches/8.3 cm*

*Height: 1¾ inches/4.4 cm*

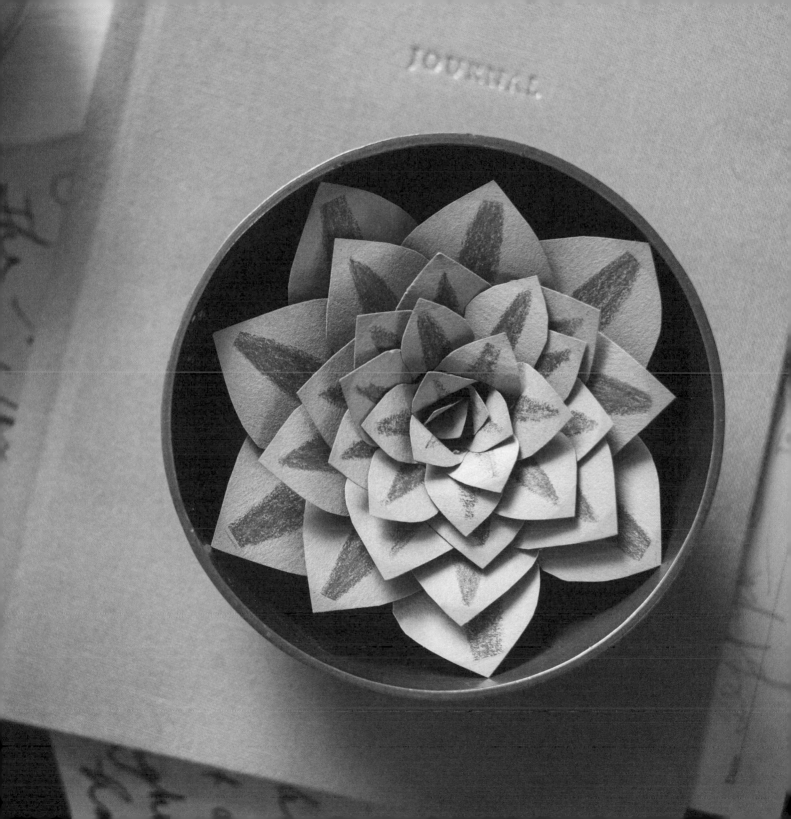

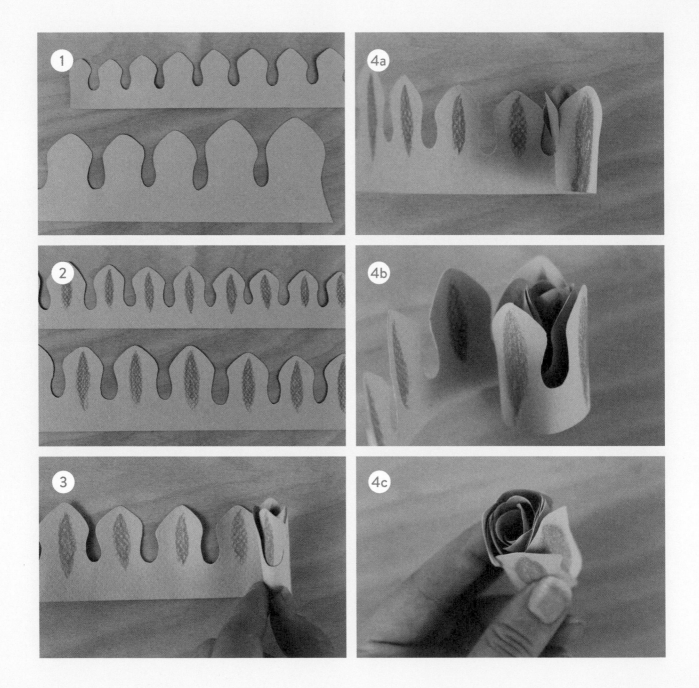

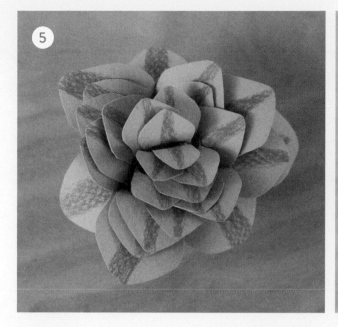

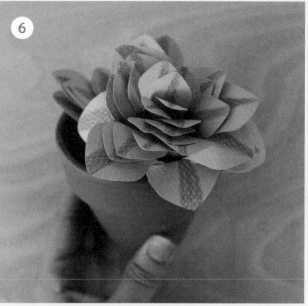

**1) Mark**

Draw wide succulent leaf shapes across a long piece of light-green paper. Have them get proportionately larger as they proceed down the line.

**Cut**

Cut them out using either an X-Acto blade or a scissors.

**2) Draw**

Use a green colored pencil to add a tapered stripe onto the center of each leaf.

**3) Bend**

Curl every leaf with the detail facing up to help them spread out later.

**4) Roll**

Starting with the smallest leaf and ending with the largest, roll the strip of leaves.

**5) Adhere**

Once your spiral is complete, loosen it up at the top, and hot glue across the bottom so that it will stay in place.

**6) Finish**

Display it in a terra-cotta pot or nice dish and add some brown or tan paper to mimic soil or sand.

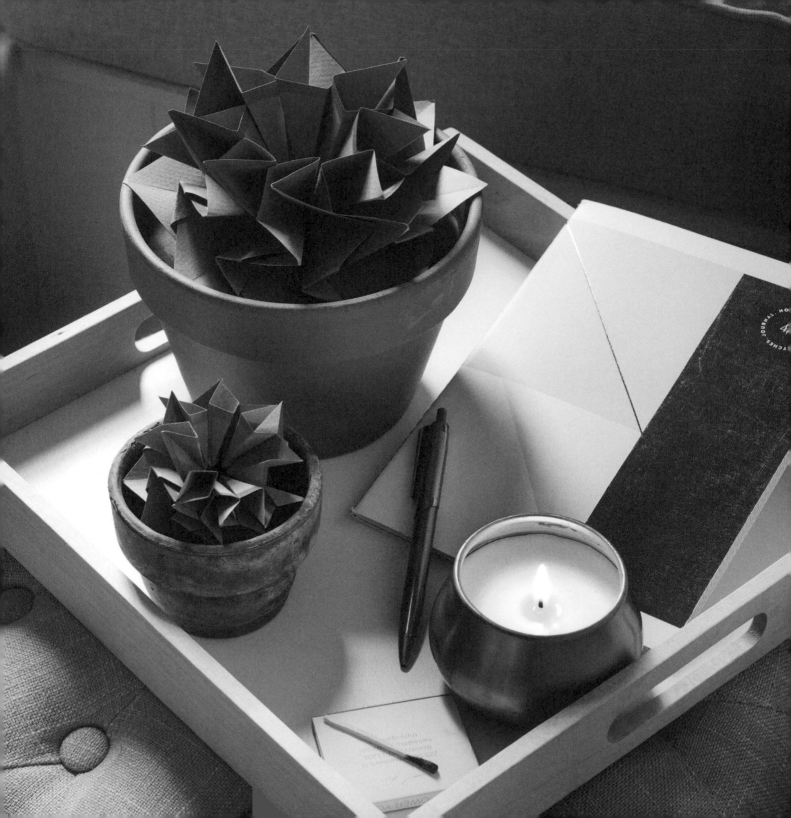

# lipstick

(PAPER, FOLD)

*Another type of Echeveria, the Lipstick or agovoides, has a distinct line of red-orange around the edges of its leaves. Like an agave, its leaves have one small spine on the tip, and the Lipstick blooms in the summer, its red flowers tipped in yellow.*

## MATERIALS

- Green paper
- Orangish-red pencil
- Scissors
- Glue (optional)

## SIZE

**Large**

*Length:* 6 inches/15.2 cm

*Width:* 6 inches/15.2 cm

*Height:* 2 inches/5.1 cm

**Small**

*Length:*
2¾ inches/7 cm

*Width:*
2¾ inches/7 cm

*Height:*
1 inch/2.5 cm

### 1) Cut

Cut eight 4-inch/10 cm and eight 2-inch/5 cm squares. You can make them smaller or larger if you prefer, as long as the smaller leaves are half the size of the larger leaves.

### 2) Draw

Get a colored pencil somewhere between orange and red to mimic the fine edges on this species of succulent. Draw along each side of the green paper.

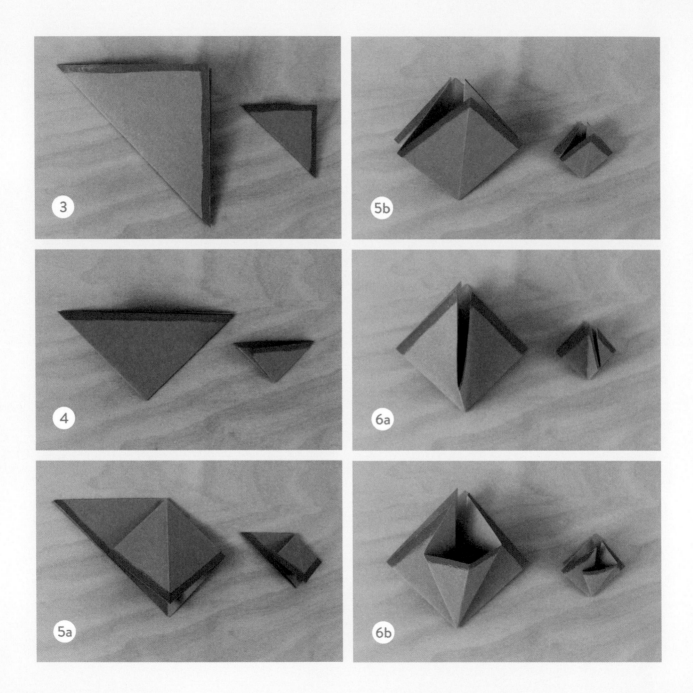

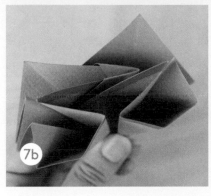

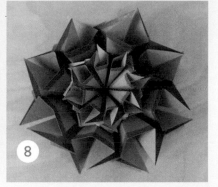

3) **Fold**

Make a triangle by folding the paper diagonally.

4) **Fold**

Fold both pieces in half again.

5) **Fold**

Bend the points on the right to make a squash fold. Repeat that action on the back.

6) **Fold**

Rotate and make a smaller squash fold.

7) **Attach**

There should be 8 identical large pieces and 8 identical small pieces. Insert the single flap on the right into the two flaps on the left of another same-size piece. Bring the point facing up on the second

piece down into the flap on the first piece to lock it in place. Repeat this action for all 8 of the large and again for all 8 of the small.

8) **Finish**

Place the smaller cluster into the center of the bigger cluster with the option to glue it in place. Set it inside of a planter or alongside other succulent arrangements.

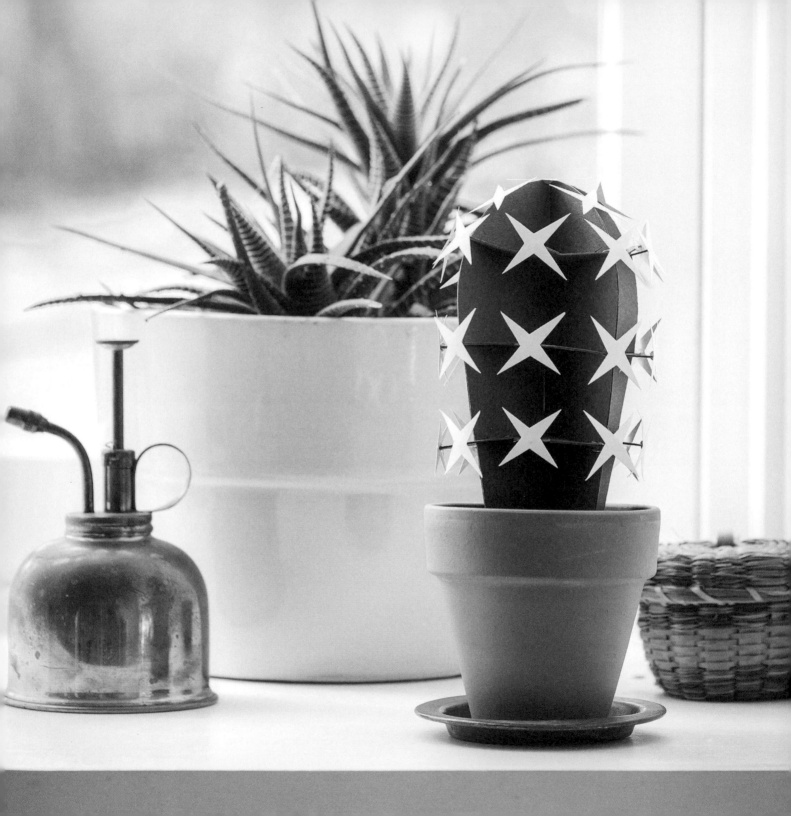

# cactaceae

### (PAPER, JOINT)

*The Latin name for the cactus family, Cactaceae, includes about 130 genera and between one and two thousand species. They range in size from ten feet tall to an inch across—but typically, this elongated spiny shape is what we think of when we picture the classic cactus.*

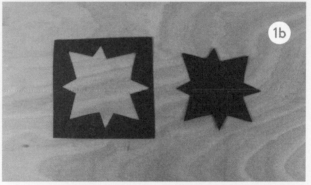

## MATERIALS

○ Green paper

○ White paper

○ Scissors or X-Acto

○ Hot glue

## SIZE

*Length: 2 inches/5.1 cm*

*Width: 3¼ inches/8.3 cm*

*Height: 6½ inches/16.5 cm*

### 1) Mark

Draw two identical oblong shapes out of green paper, approximately 8 × 4 inches/20 × 10 cm. They should have rounded tops and blunt bottoms. Draw four identical spiky shapes with at least four corners.

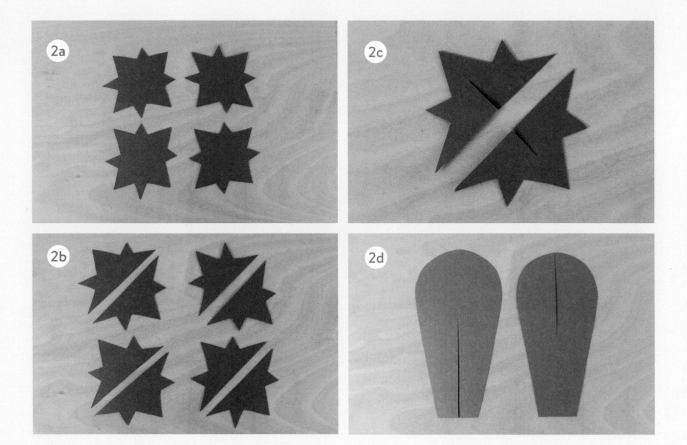

## 2) Cut

Cut out the shapes, then slice the four spiky shapes in half. Cut halfway up each spiky shape from the slice. Cut your first oblong shape halfway down from the top, and the second halfway down from the bottom, to make a slot-joint. One oblong shape will need a cut halfway from the top and the other oblong shape will need a cut halfway from the bottom to make a slot-joint. Into the sides of one oblong shape, make eight cuts, halfway from the edge.

## 3) Combine

Insert all of the spiky shapes into the cuts on the side of the oblong shape. Then insert the plain oblong shape into the slot of the other, keeping all of the shapes interlocked. If there are wiggling and unstable panels, hot glue can be applied before sliding them into place.

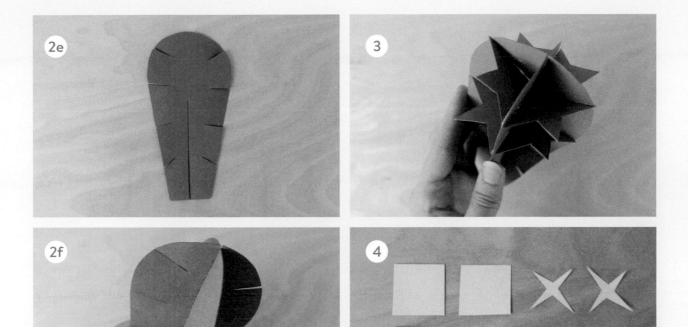

## 4) Cut

To make the Cactaceae look even more dangerous to touch, cut multiple white spikes out of paper to cover each point of the green form.

## Adhere

Apply a small amount of hot glue to the center of a small white spike and hold it in place on a green point until it dries. Repeat this action until the whole cactus is covered with spikes.

## Finish

Stick it into a terra-cotta pot with some brown paper to mimic sand.

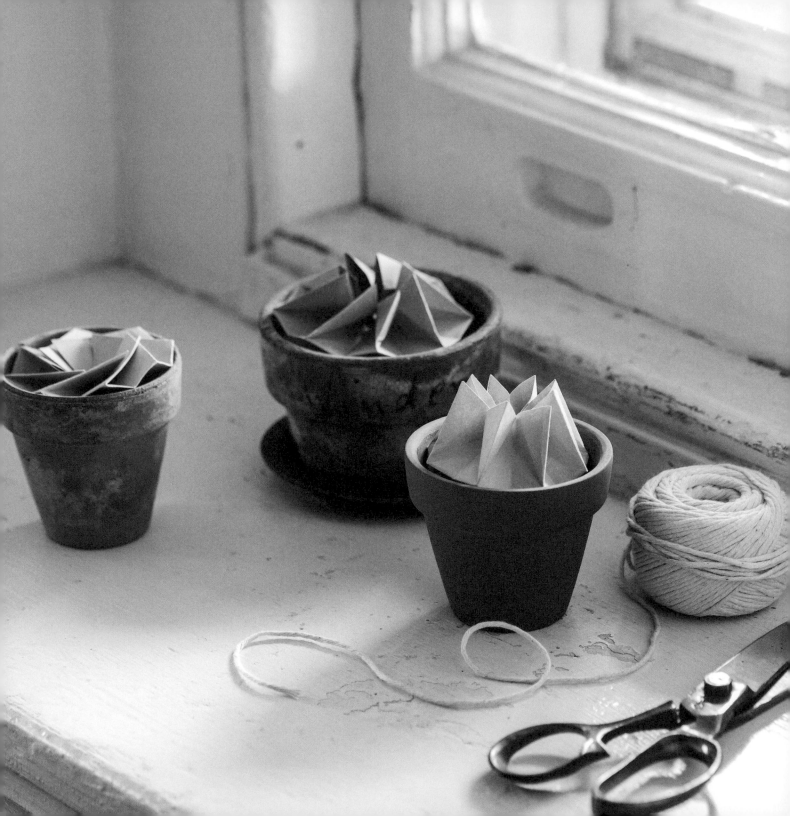

# echeveria

(PAPER, FOLD)

*Our Desert Rose, Echeveria is the most common rosette-style succulent, though it covers a wide variety of species. It can be pink, a dusky purple, orange, red, blue, or green with red tips. They can be pointed or rounded, and require sandy soil with good drainage and fairly consistent temperatures.*

## MATERIALS

○ **Green paper**

○ **Scissors**

## SIZE

Length: 2¼ inches/5.7 cm

Width: 2¼ inches/5.7 cm

Height: 1 inch/2.5 cm

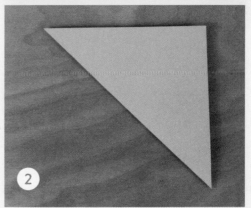

### 1) Cut

Cut a square from the green paper. The size of the square depends on the size of the planter or the area that you'd want to fit it into. Shown here as a 5-inch/12.5 cm square.

### 2) Fold

Make a triangle by folding the paper diagonally.

### 3) Fold

Fold the piece in half again.

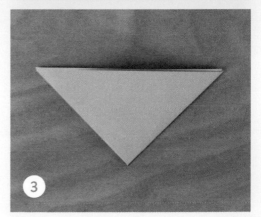

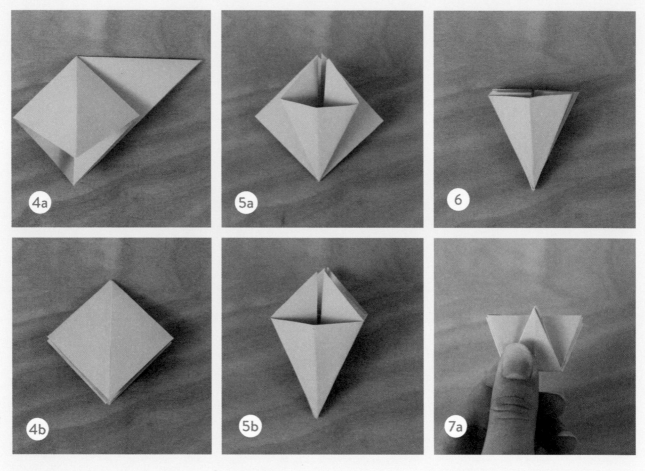

4) **Fold**

Bend the point on the side inward to make a squash fold. Repeat that action on the back.

5) **Fold**

Bend the new point on the side inward to make a smaller squash fold. Repeat on all sides.

6) **Cut**

Trim the top points off of the folded paper.

7) **Fold**

Bend the arrow at the bottom a bit past the blunt edge to create even creases when you unfold it.

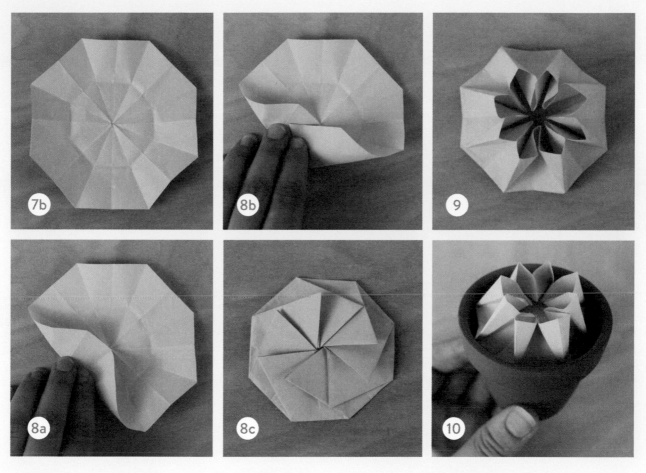

8) **Fold**

Bring one section of the outer edge toward the center and overlap the next section following the diagonal creases made in the previous folds. Repeat this action until all sections are folded over.

9) **Fold**

Bend all of the points over to make small squash folds that open upward.

10) **Finish**

Fit it into your planter or terracotta pot and make more to keep it company.

# succulent wall garden

(WOOL, FELT)

*This garden includes varieties of Hens & Chicks, echeveria, jade, and Burro's Tail.*

*Hens & Chicks, the common name for Crassulaceae, is a rosette-style succulent, so-called because of their tendency to produce a lot of babies. Along with looking like flowers, they also produce flowers, and a blooming hen on a Hens & Chicks plant is often called a "rooster."*

*Echeveria, also known as Desert Rose, is native to Mexico and Central America. It requires full sun, consistent temperatures, sandy soil with good drainage, and small containers.*

*Jade, or Crassula ovata, is also known as Friendship Tree, Lucky Plant, or Money Tree. It is native to South Africa and Mozambique and is popular for its ease of propagation and care, and its willingness to grow as instructed, as in bonsai. Although its stems appear woody, it is a true succulent, and remains fleshy beneath the brown surface.*

*Burro's Tail, or Sedum morganianum, is also known as Donkey's Tail. It is easy to grow, even among succulents, and will forgive a missed watering or a bit of a change in temperature. It looks particularly good in a hanging pot, with its teardrop-shaped leaves dangling over the edge.*

## MATERIALS

- Craft felt, in a variety of greens, perhaps with some pinks, reds, or purples

- Needle and thread

- Scissors

- Shallow wooden box, shown here in 7¾ × 14 × 1¾ inches

- Seed beads (optional)

- Craft moss (optional)

- Smooth stones (optional)

- Glue gun

## Hens & Chicks

You can make this in green, pink, red, or purple, or a combination of the above. Cut 12 2 × 1 inch/5 × 2.5 cm ovals for chicks, or 12 3 × 1½ inch/7.5 × 4 cm ovals for hens.

Fold 1 oval in half, and fold it in half again. Stitch this fold in place with a needle and thread. Don't cut the thread.

Fold 3 ovals in half and stitch them around the center piece, with the rounded edges up.

Sew 8 unfolded ovals around the edge of the center rosette. Stitch around the bottom, pulling tight to make it pucker a bit. Trim as necessary to make sure it's even.

## Echeveria

Cut 2 3 × 3 inch/7.5 × 7.5 cm squares of green felt, one in a lighter color and one in a darker color. Trim them both into rounded cross shapes with pointy ends, as pictured.

Cut 4 2½ × 2½ inch/6.5 × 6.5 cm squares of green felt, 2 in a lighter color and 2 in a darker color. Trim them into rounded cross shapes with pointy ends.

Cut 2 2 × 2 inch/5 × 5 cm squares of green felt, one in a lighter color and one in a darker color. Trim them into rounded cross shapes with pointy ends.

Layer the largest light-green cross atop the largest dark-green cross, offsetting it a bit so both layers show.

Layer one medium-sized light-green cross atop a medium-sized dark-green cross, and repeat for the second set of medium-sized crosses, again offsetting them. Layer them on top of the largest cross stack, fanning them out so all the leaves are visible.

Layer and offset the smallest light-green cross atop the smallest dark-green cross, and place them at the center of your cross stack.

Insert a needle and thread through the bottom of the stack, up through the center of the top. Thread a seed bead onto your needle, and stitch it in place, holding the stacks together.

Use your scissors to trim the tips as needed so it all looks nice and even.

## Jade

This can be made in various shades of green.

Take a 4 × 4 inch/10 × 10 cm piece of felt and cut it into a 1-inch/2.5 cm–thick spiral.

Cut deep, 1-inch/2.5 cm–wide scallops into the outside edges of the spiral.

Starting from the center of the spiral, roll up your jade, and insert the tail end through the hole in the center. Stitch in place with a needle and thread, gathering the underside of the jade together.

## Burro's Tail

This can be made in various shades of green.

Take a 3 × 3 inch/7.5 × 7.5 cm piece of felt and cut it into a spiral ½ inch/1.5 cm thick.

Start from the center of the spiral, and wind the edges so that the spiral grows longer, rather than wider. Stitch in place as you go, until the spiral is about 2 inches/5 cm long.

## Assembly

Begin by hot gluing the moss in place, covering the entire area of your box. Scatter the rocks around, and then hot glue them in place. Nestle your succulents around the rocks as desired, hot gluing and tucking them near or under each other, grouping them together—or not.

whimsical

# plants

## pink trumpet vine

(WOOL, KNIT)

*Pink trumpet vine, or Podrane ricasoliana or Queen of Sheba, is a warm-weather-loving, fragrant, fast-growing perennial. It is, in fact, so fast-growing that many gardeners consider it a pest—and it grows faster as it matures.*

*But bees and hummingbirds adore it, and it blooms from spring through fall. Attach it to a trellis, trim it often, and it will provide lovely, sweet-smelling privacy.*

## MATERIALS

- US 5/3.75 mm set of 4 double-pointed needles

- 250 yards/229 meters worsted or DK weight yarn (shown in Madelinetosh Tosh DK, in colors MC Shire, and CC Night Bloom)

- Tapestry needle

- Scissors

## SIZE

*Length: 56 inches/124.2 cm*

*Width: 2 inches/5.1 cm*

## FLOWERS (make 9, or as many as desired)

With CC, cast on 4 sts. Divide sts over 3 dpn with 1 st on each of two needles, and 2 sts on third needle. Pm and join to work in the rnd, being careful not to twist sts.

**Rnd 1:**
Knit.

**Rnd 2 (inc):**
*Kf&b; repeat from * around—8 sts.

**Rnd 3:**
Knit.

**Rnd 4 (inc):**
*K1, kf&b; repeat from * around—12 sts.

**Rnds 5 and 6:**
Knit.

**Rnd 7 (inc):**
*K2, kf&b, repeat from * around—16 sts.

**Rnds 8–10:**
Knit.

**Rnd 11 (inc):**
*K3, kf&b; repeat from * around—20 sts.

**Rnds 12–15:**
Knit.

**Rnd 16 (fold line):**
*Yo, k2tog; repeat from * around.

**Rnds 17–19:**
Knit.

**Rnd 20 (dec):**
*K3, k2tog; repeat from * around—16 sts remain.

**Rnds 21 and 22:**
Knit.

**Rnd 23 (dec):**
*K2, k2tog; repeat from * around—12 sts remain.

**Rnd 24:**
Knit.

**Rnd 25 (dec):**
*K1, k2tog; repeat from * around—8 sts remain.

**Rnd 26 (dec):**
*K2tog; repeat from * around—4 sts remain.

Break yarn, leaving an 8-inch/20.5 cm tail. Thread tail into tapestry needle and draw through the remaining sts, pulling tight to close hole. Fold the shorter end (last 11 rnds) to inside of the flower along the fold line. Weave in ends.

## LEAVES (make 21, or as many as desired)

With MC, cast on 4 sts. Divide sts over 3 dpn, with 1 st on each of two needles, and 2 sts on third needle. Pm and join to work in the rnd, being careful not to twist sts.

**Rnd 1:**
Knit.

**Rnd 2 (inc):**
*Kf&b; repeat from * around—8 sts.

**Rnd 3:**
Knit.

**Rnd 4 (inc):**
Kf&b, k2, (kf&b) twice, k2, kf&b—12 sts.

**Rnd 5:**
Knit.

**Rnd 6 (inc):**
Kf&b, k4, (kf&b) twice, k4, kf&b—16 sts.

**Rnds 7 and 8:**
Knit.

**Rnd 9 (dec):**
(Ssk, k4, k2tog) twice—12 sts remain.

**Rnds 10 and 11:**
Knit.

**Rnd 12 (dec):**
(Ssk, k2, k2tog) twice—8 sts remain.

**Rnds 13 and 14:**
Knit.

**Rnd 15 (dec):**
(Ssk, k2tog) twice—4 sts remain.

**Rnd 16 (dec):**
Ssk, k2tog—2 sts remain.

Break yarn, leaving an 8-inch/20.5 cm tail. Thread tail into tapestry needle and draw through the remaining sts, pulling tight to close hole. Weave in ends.

### Vine

With dpn and MC, pick up and knit 4 sts around the base (cast-on edge) of one flower.

Work an I-cord as follows:

**Row 1:**
K4 but do not turn, slide sts to right end of the double-pointed needle.

**Row 2:**
Bring yarn across the back of the needle, pull it tight, k4 but do not turn, slide sts to right end of needle.

Repeat row 2 until the I-cord measures 2 inches/5 cm long.

### Attach leaf

With another dpn, pick up 2 sts in the base of a leaf.

**Next row:**
K1 I-cord st, holding dpn with leaf in front, (knit together 1 st from the I-cord with 1 st from leaf) twice, then knit remaining I-cord st, do not turn—4 sts.

*Work I-cord for 2 inches/5 cm. Attach another leaf in the same manner. Repeat from * once more. Work I-cord for 2 inches/5 cm. Attach a flower in the same manner.

Continue to alternate one flower between 3 leaves until you have no leaves, and only one flower left. Work I-cord for 2 inches/5 cm. Join the remaining flower. Break yarn, leaving an 8-inch/20.5 cm tail. Thread tail into the tapestry needle and draw through the remaining sts, pulling tight to close hole. Weave in ends.

# toadstool

(WOOL, NEEDLE FELT)

*Commonly known as fly agaric or Amanita muscaria, this iconic toadstool is famous for forming fairy circles—mysterious rings of mushrooms which, if stepped in, can whisk you away to fairy land, where you will remain for seven times seven years.*

*It is classified as poisonous, though it is rarely deadly. It is known to be hallucinogenic, however. Cultures across the world have been known to parboil and consume the mushroom, both for recreational and religious practices. Note that it is not the mushroom most commonly used for this purpose, which are psilocybin mushrooms; fly agarics are usually found sheltering ladybugs from rainstorms.*

## MATERIALS

- Felting needle
- Champagne cork, wine cork
- ½ oz white wool roving
- ¼ oz red wool roving
- Hot glue (optional)

## SIZE

**Bulbed Short**

*Length: 2 inches/5.1 cm*

*Width: 2 inches/5.1 cm*

*Height: 2 inches/5.1 cm*

**Bulbed Tall**

*Length: 2½ inches/6.4 cm*

*Width: 2½ inches/6.4 cm*

*Height: 4½ inches/11.4 cm*

**Flat Short**

*Length: 3½ inches/8.9 cm*

*Width: 3 inches/7.6 cm*

*Height: 2 inches/5.1 cm*

**Flat Tall**

*Length: 4 inches/10.2 cm*

*Width: 3½ inches/8.9 cm*

*Height: 4½ inches/11.4 cm*

## Bulbed Toadstool

Wrap cylinder of champagne cork with white roving and needle felt in place.

Cover bulb of champagne cork with white roving and needle felt in place.

Cover bulb of champagne cork with a layer of red roving and needle felt in place.

Form small balls with white roving and needle felt them onto the red roving, as desired.

## Flat Toadstool

Wrap the cylinder of a wine cork with white roving and needle felt it in place. Create a shallow bowl of red roving, and needle felt it until it is stiff. Needle felt it to the top of the cork. Form small balls with white roving and needle felt them onto the red roving as desired.

To make taller toadstools, glue a wine cork to the champagne cork, or a second wine cork to the first wine cork.

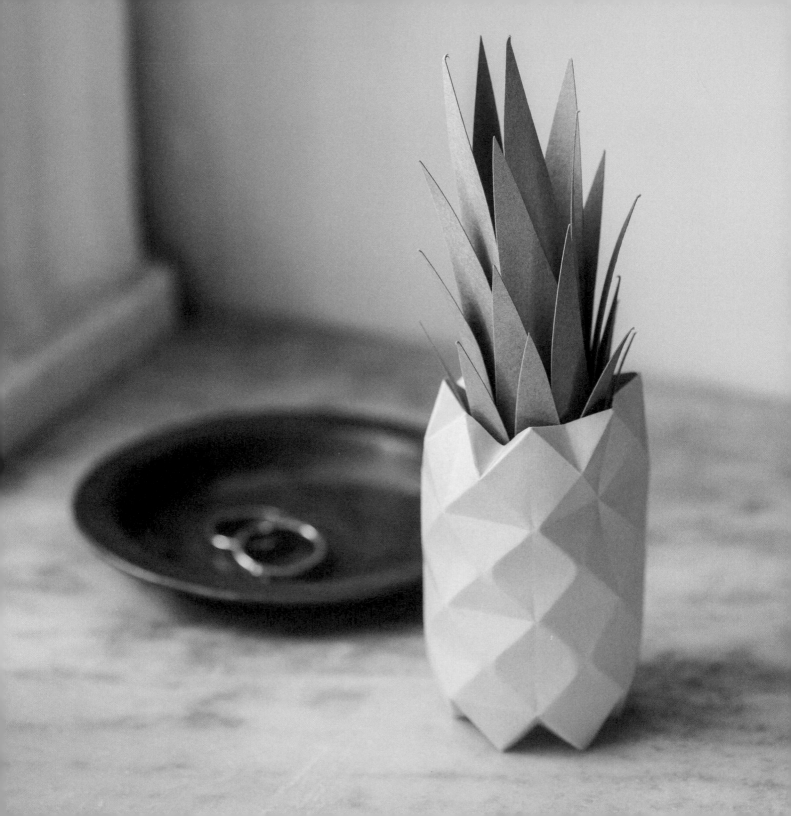

# pineapple

(PAPER, FOLD)

*The pineapple's sweet, citrusy fruit is not one whole, but a composite of coalesced berries. While "pineapple" today refers to the tropical Ananus comosus, it was the original name for pinecones—and when Westerners came across the fruit in their travels, it obviously resembled those reproductive organs of conifers and the name stuck, though really it makes no sense at all.*

## MATERIALS

○ Yellow paper

○ Light-green paper

○ Scissors or X-Acto

○ Glue stick or tape

## SIZE

*Length: 1 inch/2.5 cm*

*Width: 1¾ inches/4.4 cm*

*Height: 5½ inches/13.9 cm*

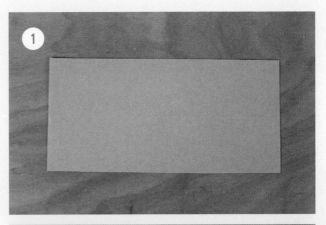

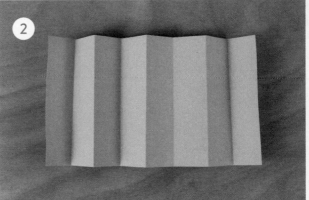

### 1) Cut

Make the length of the yellow paper twice the size of the height. The one pictured in the examples is 6 × 3 inches/15 × 7.5 cm.

### 2) Fold

Then create an even accordion fold. Consistently fold the paper back and forth, or fold the paper in half and fold those halves in half and repeat until you have multiple peaks.

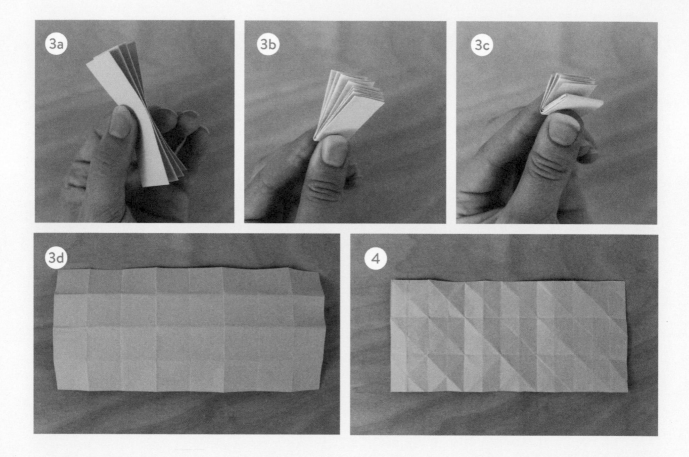

### 3) Fold

Squeeze the accordion fold together and bend it in half, then bend it in half again. These folds will create a grid when you unfold it.

### 4) Fold

Fold the paper diagonally along each square.

### 5) Adhere

Connect the sides of the folded paper together with a glue stick or tape, making sure it makes a seamless pattern out of the triangles you just folded.

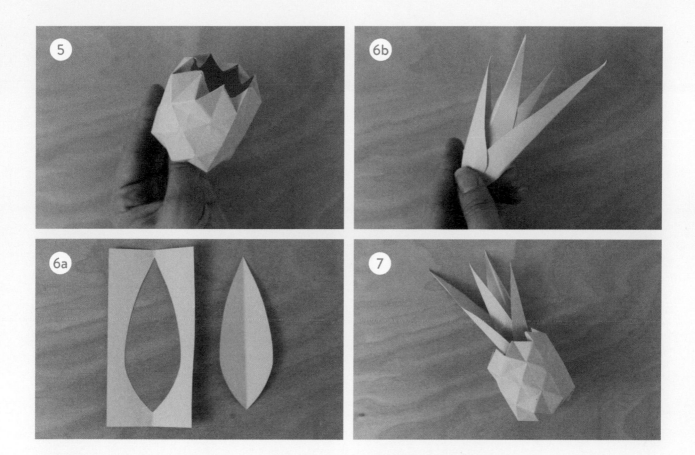

### Fold

Bend the areas at the top and bottom of the pineapple body to move inward, creating a base.

### 6) Cut

Cut out a few symmetrical elongated leaves with green paper by folding it in half.

### 7) Adhere

Tuck the leaves inside of the pineapple body and tape them in place through the bottom.

# pear

(WOOL, NEEDLE FELT)

*Pear, or Pyrus, is a member of the rose family. The trees are cultivated for their shade and ease of growth, as well as their flowers, whose petals scatter like snow in the spring. And, of course, they are beloved for their fruit, which is sweet, stores well, and ripens on demand (though it does require frequent checking).*

## MATERIALS

- Felting needle
- Foam pad, at least 2 inches thick (often sold with felting needles)
- 2 oz bright-green wool roving
- ¼ oz brown wool roving
- ¼ oz darker-green wool roving

## SIZE (WILL VARY)

*Length: 2 inches/5.1 cm*

*Width: 2 inches/5.1 cm*

*Height: 4¼ inches/10.8 cm*

### Pattern

Make a child's fist–sized ball of bright-green roving, and needle felt it until it is relatively firm.

Make an infant's fist–sized ball of bright-green roving, and needle felt it until it is relatively firm.

Needle felt the smaller ball on top of the larger ball, like a snowman. Work until they are secured together and both balls are quite firm.

Wrap a ribbon of bright-green roving around the place where the two balls were joined together. Needle felt this ribbon in place, smoothing out the join.

Needle felt as needed, wherever the pear needs smoothing, particularly on the bottom, to make it flat.

Roll a bit of brown roving into a small stem shape. Place it on the foam pad and needle felt it until it is firm, rotating the stem so it remains round.

Stand the stem upright on the pear and needle felt it in place, until it feels very secure.

Take a bit of dark-green roving and form a basic leaf shape. Lay the leaf on top of the foam pad and needle felt it until it holds its shape and is very stiff.

Carefully attach the leaf to the stem. It's easy to stab yourself here, so go slowly, but be sure to be thorough, otherwise the leaf will fall off.

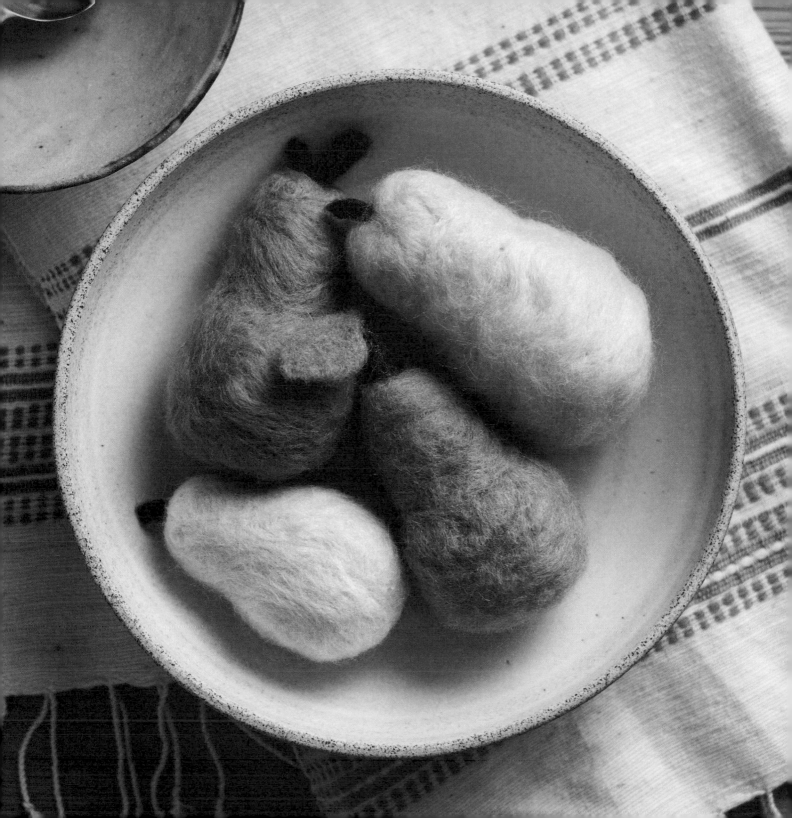

# garlic

(PAPER, JOINT)

*A close relative of the onion, garlic, or Allium*
*sativum, has been used as a culinary seasoning,*
*as well as a traditional medicine, for*
*thousands of years. It has been used to treat*
*anything from sunburn to smallpox, and has*
*been called the "rustic's theriac" or cure-all.*

## MATERIALS

- Heavy white cardstock
- Scissors or X-Acto
- Hot glue (optional)

## SIZE

*Length:* 4 inches/10.2 cm

*Width:* 7½ inches/19 cm

*Height:* 15¾ inches/40 cm

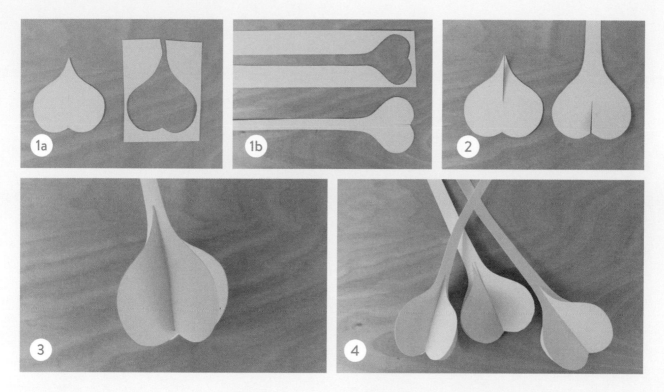

## 1) Mark

Draw out a garlic shape with a pointed top and rounded bottom on heavy white cardstock. Draw a second version of the same garlic shape that has a long stalk. The braid will require multiple strands of garlic, so around 10 of these sets are recommended for volume.

## 2) Cut

Cut each of the shapes out with scissors. To create a slot-joint, the short piece needs a snip starting at the top and ending at the center. Then the long piece needs a snip at the bottom.

## 3) Connect

Take the shorter piece and slide it into the bottom of the longer piece. This locks them together and creates a simplified bulb of garlic. Repeat this action with all of your pieces.

## 4) Braid

Then lay three of your pieces down and start braiding the long strands, introducing new strands as you go.

## Finish

Once the bunch is all braided you can hang it in your window to guard against vampires.

# lawson's cypress

(WOOL, CROCHET)

*Lawson's cypress, also known as Chamaecyparis lawsoniana or Port Oxford cedar, is a tall evergreen, found often on the banks of streams in the Pacific Northwest. It is generally slightly bluish in color, and can grow up to 200 feet tall, with a trunk diameter of 7 feet. Its lumber smells strongly of ginger, and is valued across the world; it is frequently shipped to Japan, where it is used to build coffins, shrines, and temples.*

*It is currently under threat—its roots are being attacked by a pathogen known as Phytophthora lateralis, which travels through the streams the cypress lives alongside, as well as on the shoes and tires of people moving through the woods.*

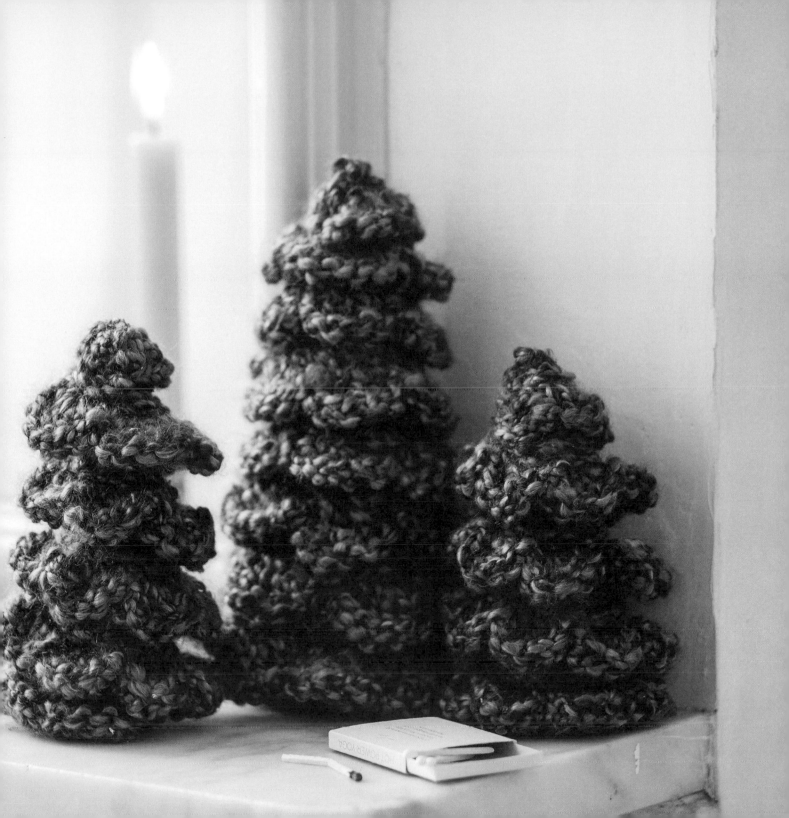

## MATERIALS

- US J-10/6 mm crochet hook
- 70 (100) yards/64 (91) meters bulky weight yarn (shown in Lion Brand Homespun, in color Forest)
- Fiberfill stuffing
- Tapestry needle
- Scissors

## SIZE

**Tall**

*Length: 4½ inches/11.4 cm*

*Width: 4½ inches/11.4 cm*

*Height: 8½ inches/21.6 cm*

**Short**

*Length: 3½ inches/8.9 cm*

*Width: 3½ inches/8.9 cm*

*Height: 6 inches/15.2 cm*

## Body of Tree

**Foundation ring:**
Ch 16 (20), join in the rnd with a sl st in first ch to form a ring.

**Next rnd:**
Ch 1, sc in each ch around. Do not join—16 (20) sts.

**Next rnd:**
Sc in each st around. Do not join.

Repeat last rnd 1 (0) more time(s).

**Dec rnd:**
*Sc in each of next 2 sts, sc2tog; repeat from * around—12 (15) sts remain.

Work 3 (2) rnds even.

**Dec rnd:**
*Sc in next st, sc2tog; repeat from * around—8 (10) sts remain.

### Size Small Only:

Work 3 rnds even.

**Dec rnd:**
*Sc2tog; repeat from around—4 sts remain.

### Size Large Only:

Work 3 rnds even.

**Dec rnd:**
*Sc2tog; repeat from * around—5 sts remain.

Work 3 rnds even.

**Dec rnd:**
Sc2tog, sc in next st, sc2tog—3 sts remain.

**Both Sizes:**

Fasten off.

**Base**

**Foundation ring:**
Ch 3, join in the rnd with a sl st in first ch to form a ring.

**Rnd 1:**
Ch 1, work sc 9 around ring. Do not join—9 sts.

**Rnd 2:**
Sc in each st around. Do not join.

**Size Large Only:**

**Inc rnd:**
*2 sc in next st; repeat from * around—18 sts.

**Both Sizes:**

Do not break yarn.

**Attach Base to Body**

Stuff tree with fiberfill to reasonable firmness. Sl st base to bottom of body of the tree. Fasten off.

**Branches**

**Foundation ch:**
Ch 60 (90). Do not join.

**Row 1:**
Skip 3 ch, sc in next ch, *ch 1, skip next ch, sc in next ch; repeat from * to end—29 (44) sc and 28 (43) ch-sps.

**Next row:**
Ch 1, work 4 dc in ch-sp, sl st in sc, *5 dc in next ch-sp, sl st in next sc; repeat from * to end.

Do not break yarn.

**Attach Branches to Body**

Winding branches up the side of the tree as you work, begin at the base of the tree, and join the first st of the foundation ch to the side of the tree with a sc. Working along the foundation ch of branches, continue up and around the tree.

When you reach the top, you should have a few remaining inches/cm of branches. Sc these sts together to make the top of the tree nice and pointy.

Fasten off.

Weave in ends, reinforcing the attachment of the branches to the tree as necessary.

# teacup garden

### (WOOL, NEEDLE FELT)

*Maidenhair spleenwort, also known as Asplenium tricomanes, is a small curling fern that typically grows between rock crevasses.*

*Blue Italian cypress, or Cupressus sempervirens glauca, is a tall and extremely thin fir tree, often grown for decoration, to border driveways, or to act as a windbreak. It is a startling blue-green in color.*

*King bolete mushrooms, also known as Boletus edulis—as well as porcini, cep, steinpilz, penny bun, and many other names—are large, meaty, and edible mushrooms that can be found growing beneath hemlock and oak trees, particularly when sphagnum mosses are present. Their caps can grow between 2 and 10 inches in diameter.*

*Forget-me-nots, or Myosotis or scorpion grass, are tiny blue flowers that grow in large numbers, particularly in wet soil, such as along riverbanks or near marshes. For such tiny flowers, they have inspired a great number of legends and stories, and are considered a sign of remembrance, faithfulness, and love.*

*Acorns are the nuts of the oak tree. They typically contain two seeds nestled within a hard shell, nestled within a cupule, or cap. Acorns play a critical role in forest ecology, as they provide a source of food for a wide variety of creatures, from squirrels and chipmunks to deer, rabbits, and crows.*

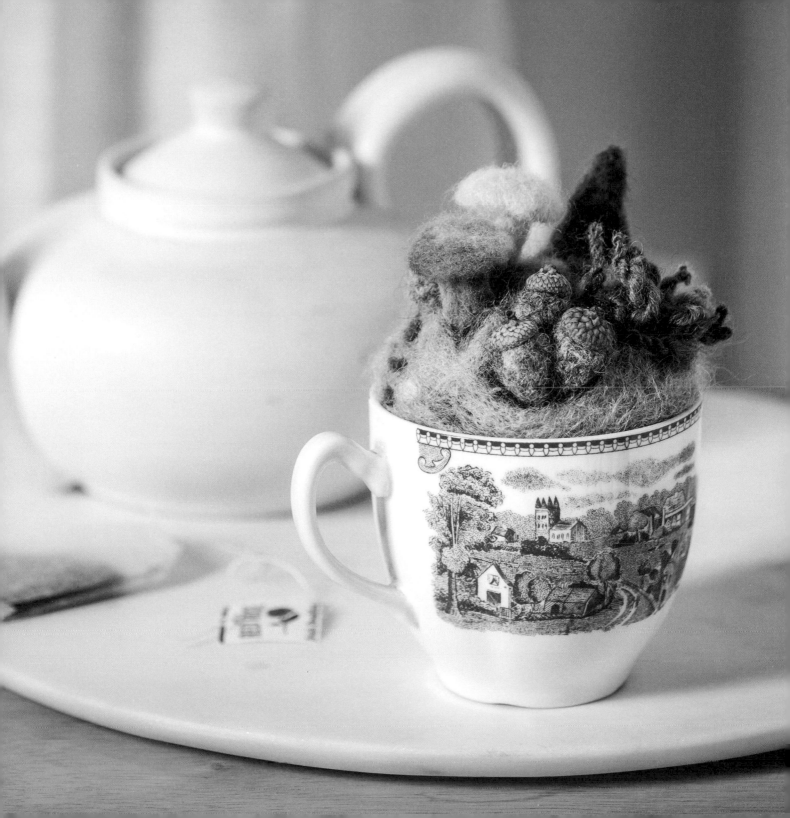

## MATERIALS

- Felting needle
- Foam pad, at least 2 inches/5 cm thick
- Felt sheet(s) (optional)
- 4 oz of wool roving, in a variety of blues, greens, grays, and browns
- Acorn caps
- Hot glue gun
- Teacup

## SIZE

*Length: 2½ inches/6.4 cm*

*Width: 2½ inches/6.4 cm*

*Height: 4 inches/10.2 cm*

*Note: Because of the teacup garden's nature, the plants shown here are obviously neither true to size nor scaled correctly. Feel free to be even more whimsical, and add fairy houses, paths, strange and unusual flowers—whatever suits your fancy.*

### Hill

Stuff the cup with felt sheets, or use roving if you have plenty of extra. Cover with a thick layer of brown roving and needle felt it in place until it resembles a rounded hill.

### Maidenhair Spleenwort

Twist a thin, 3-inch/7.5 cm strip of green wool until it begins to curl in on itself. Needle felt that curl onto the hill so that it is standing upright. Repeat as desired.

### Acorns

Wet your palms with water and roll a small ball of gray felt until it begins to hold its shape. Needle felt it until it stiffens. Place a dab of hot glue into the acorn cap and place the needle-felted acorn inside the cap. Repeat as desired, and needle felt the acorns onto the hillside.

### King Boletes

Take a small amount of light-brown wool and shape it into something like the cap of a mushroom. Needle felt it to stiffen it, using the foam pad.

Roll a thin stem and stiffen it with your needle—in this case, make it quite stiff as it will need to hold up the cap—and then needle felt the cap to the stem, and the stem to the hillside. Repeat as desired.

### Blue Italian Cypress

Make a thin, 3-inch/7.5 cm strip of blue-green wool. Wind it into a coil and needle felt it onto the hillside. Make a smaller coil, and needle felt it on top of the first coil. Repeat with an even smaller coil, or until you reach your desired height.

Wrap more thin strips around the tree and needle felt them in place, until it reaches desired firmness.

### Grass

Cover the hillside with a thin layer of light-green roving and needle felt it in place.

### Forget-me-nots

Take tiny pieces of blue wool and roll them into tiny balls, and needle felt them into place on the hillside, stabbing several times through the center of the balls to make them dimple.

# terrarium

(WOOL, CROCHET)

*Cushion moss, or Leucobryum, prefers wet sandy soil, frequently near swamps, where it will grow in round clumps at the base of trees.*

*Fiddlehead ferns, or young, uncurled ferns, prefer light shade, but are really happy enough anywhere as long as the ground is moist. Certain varieties can be consumed, but they should be cooked first to remove the coating of shikimic acid, a carcinogenic.*

*Rope hoya, also known as Hoya carnosa or Hindu rope plant, is a remarkably twisty succulent. It would normally never grow in a damp environment like a terrarium, as it prefers good drainage, but certain liberties can be taken.*

## MATERIALS

- US C-2/2.75 mm crochet hook
- US F-5/3.75 mm crochet hook
- 60 yards/55 meters worsted weight yarn (Malabrigo Merino Worsted, in colors Forest, Frank Ochre, Lettuce, and Apple Green)
- 40 yards/37 meters DK weight yarn (shown in Madelinetosh Tosh DK, in colors Shire and Fir Wreath)
- 20 yards/18 meters DK weight yarn (shown in Rowan Pure Wool Superwash DK, in color Dust)
- Tapestry needle
- Scissors
- 20-gauge floral wire
- 6½-inch/16.5 cm hanging glass terrarium
- Fiberfill stuffing (tiny amount)
- Double-sided tape (optional)

## SIZE

*Length: 5 inches/12.7 cm*

*Width: 9 inches/22.9 cm*

*Height: 1½ inches/3.8 cm*

### Cushion Moss (make 4)

### Foundation ring:
With larger crochet hook and worsted weight yarn, ch 8, join in the rnd with a sl st in first ch to form a ring.

### Rnds 1–3:
Ch 1, sc in each st around, join with a sl st in top of first sc—8 sts.

### Rnd 4 (dec):
Ch 1, (sc2tog) 4 times—4 sts remain.

Break yarn, leaving an 8-inch/20.5 cm tail. Thread tail from foundation ring into tapestry needle, weave tail through foundation ch, pulling tight to close the hole at the top. Push ends to inside of the bowl, and fill

ends to inside of the bowl, and fill with stuffing. Weave the remaining tail through the top of the last rnd, pulling tight to close the hole.

Using the remaining worsted weight yarn colors, make 3 more.

### Fiddlehead Ferns (make 4)

### Foundation ch:
With smaller crochet hook and one of the DK weight yarn colors (shown here in Madelinetosh Tosh DK, color Shire), ch 17.

### Row 1:
Begin in the second ch from hook, work 3 sc in each ch to end—48 sts.

Fasten off. Thread tapestry needle with the floral wire. Weave the floral wire through the foundation ch. Weave in ends. Curl one end over.

### Rope Hoya (make 3)

**Foundation ch:**

With smaller crochet hook and the other color of the same DK weight yarn (shown here in Madelinetosh Tosh DK, color Fir Wreath), ch 19.

**Row 1:**

Begin in the second ch from hook, work 2 sc in each st to end, turn—36 sts.

**Row 2:**

Ch 1, work 1 sc in first st at base of beginning ch, then work 2 sc in each st to end—72 sts.

Fasten off. Weave in ends.

### Base

**Foundation ring:**

With larger crochet hook and the remaining DK weight yarn (shown here in Rowan Pure Wool Superwash DK, color Dust), ch 4, join in the rnd with a sl st to form a ring.

**Rnd 1:**

Ch 1, work 8 sc around foundation ring, join with a sl st in top of first sc—8 sts.

**Rnd 2 (inc):**

Ch 1, work 2 sc in each st around, join with a sl st in top of first sc—16 sts.

**Rnd 3 (inc):**

Ch 1, *work 2 sc in next st, sc in next st; repeat from * around, join with a sl st in top of first sc—24 sts.

**Rnd 4 (inc):**

Ch 1, *work 2 sc in next st, sc in each of next 2 sts; repeat from * around, join with a sl st in top of first sc—32 sts.

**Rnd 5 (inc):**

Ch 1, *work 2 sc in next st, sc in each of next 3 sts; repeat from * around, join with a sl st in top of first sc—40 sts.

**Rnd 6 (inc):**

Ch 1, *work 2 sc in next st, sc in each of next 4 sts; repeat from * around, join with a sl st in top of first sc—48 sts.

Fasten off. Weave in ends.

### Finishing

Attach the cushion moss pieces to the base using the brown DK weight yarn.

Attach the fiddlehead ferns to the base in the same manner, standing them up and clumping them together at the back so they can lean on each other and on the wall of the terrarium.

Attach one end of each Rope Hoya plant strand to the base, allowing the remaining end to hang down and letting it curl freely.

Tuck the base into the terrarium, securing with double-sided tape if desired.

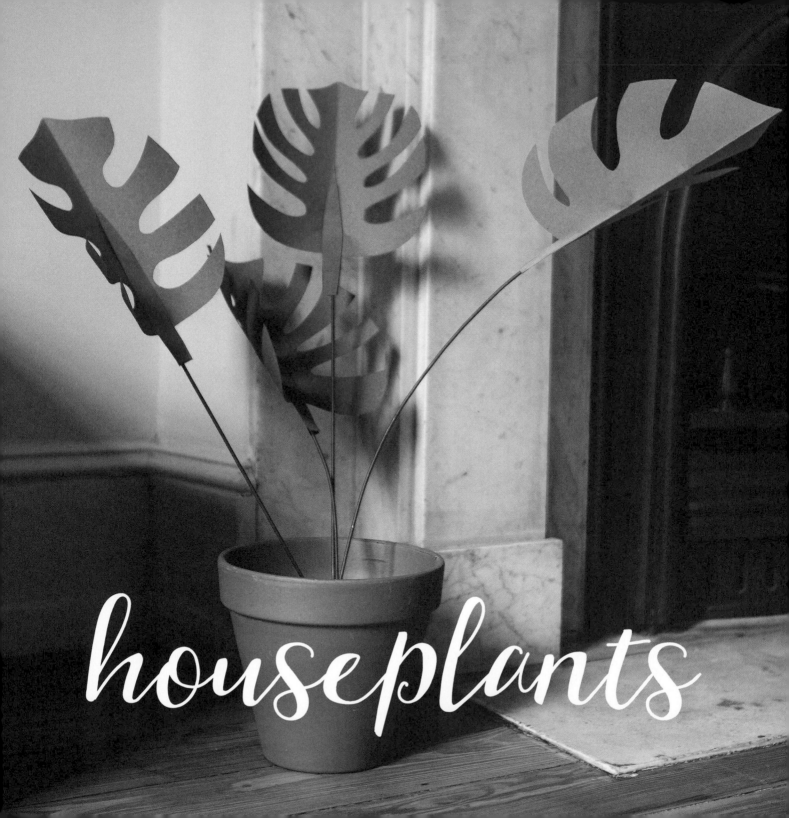

houseplants

# monstera

## (PAPER, LAYER)

*Monstera, also known as Swiss cheese plant, has very large leaves, cut with regular holes. Like ivy, they are evergreen vines, and use their aerial roots to hook over branches above, though they do maintain roots in the ground as well. One variety is cultivated for its fruit, which has a flavor somewhere between a banana and a pineapple.*

## MATERIALS

○ Green cardstock, at least 10 inches square

○ Scissors or X-Acto

○ Hot glue

○ Very thick wire

## SIZE

*Width: 24 inches/61 cm*

*Height: 25 inches/63.5 cm*

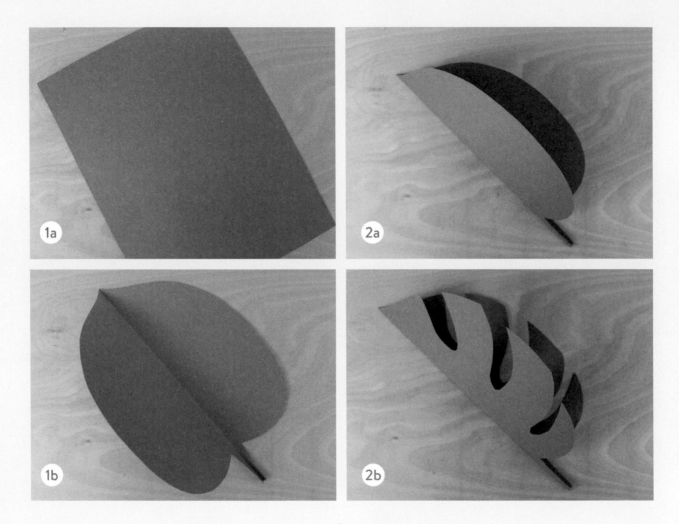

## 1) Cut

Fold a piece of large green cardstock in half. Cut out the curved and pointed shape of a Monstera leaf.

## 2) Cut

Fold the piece back and cut out rounded oblong shapes along the edge of the leaf so that the detail is symmetrical. Make a few of these leaves. There is no need for perfection, since each one should feel different from the rest.

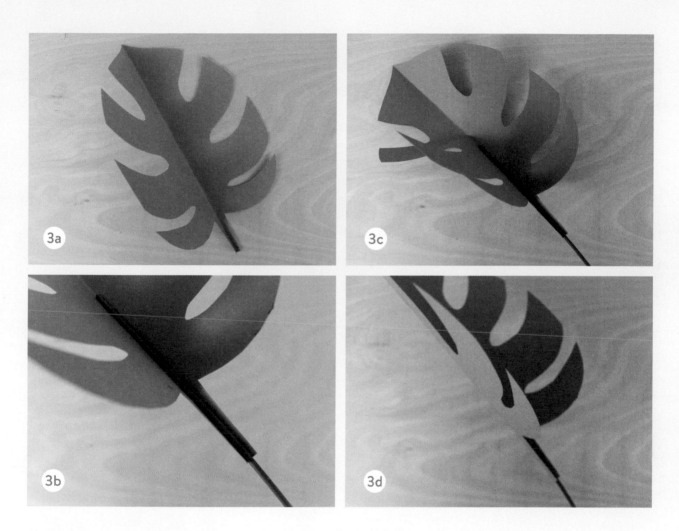

3a

3c

3b

3d

## 3) **Attach**

Apply a small amount of glue to the inside of the
leaf for a thick piece of wire to hold on to. Press it in
place until it dries. Make three or four of these
long stalks.

## 4) **Finish**

Stick the thick stems in a piece of cardboard or
Styrofoam that fits inside your planter and cover it
with brown paper to mimic soil.

# holly fern

(WOOL, KNIT)

*Holly fern, Japanese holly fern, or*
*Cyrtomium falcatum, is a common plant*
*native to eastern Asia, where it grows in*
*crevices, coastal cliffs, and other moist,*
*hidden areas, and it has 6–10 pairs of*
*shiny bright green, somewhat leathery*
*leaflets tapering up its stem. It grows*
*well indoors or outdoors, appreciating*
*shade and a temperate climate.*

## MATERIALS

- Two US 2/2.75mm double-pointed needles
- 30 yards/27 meters sport weight yarn (shown in Madelinetosh Tosh Sport, in color Forestry)
- Tapestry needle
- Scissors
- Floral wire, 18 gauge (optional)

## SIZE

*Length: 15¼ inches/39.4 cm*

*Width: 6 inches/15.2 cm*

## Leaves (make 9)

Cast on 3 sts, leaving a 6-inch/15 cm tail.

**Rows 1–4:**
Knit.

**Row 5 (inc):**
(K1, yo) twice, k1—5 sts.

**Row 6:**
Knit.

**Row 7 (inc):**
K2, yo, k1, yo, k2—7 sts.

**Row 8:**
Knit.

**Row 9 (inc):**
K3, yo, k1, yo, k3—9 sts.

**Rows 10–12:**
Knit.

**Row 13 (dec):**
K1, ssk, k3, k2tog, k1—7 sts remain.

**Rows 14 and 15:**
Knit.

**Row 16 (dec):**
K1, ssk, k1, k2tog, k1—5 sts remain.

**Rows 17 and 18:**
Knit.

**Row 19 (dec):**
Ssk, k1, k2tog—3 sts remain.

**Row 20 (dec):**
Sl 1, k2tog, psso—1 st remains.

Fasten off remaining st, leaving a 6-inch/15 cm tail.

## Stem

Make an I-cord as follows:

Cast on 3 sts.

**Row 1:**
K3 but do not turn, slide sts to right end of the needle.

**Row 2:**
Bring yarn across the back of the needle, pull it tight, k3 but do not turn, slide sts to right end of the needle.

Repeat row 2 until stem is 15 inches/38 cm long. Break yarn and draw through all 3 sts, pull tight to fasten off.

### Attaching Leaves

Using the cast-on tail threaded into tapestry needle, sew a leaf to the top of the stem. Sew the remaining eight leaves along the stem as pictured, spaced about 2 inches/5 cm apart. Weave in ends.

### Finishing

If you want your fern to stand upright in a vase, thread tapestry needle with the floral wire. Weave the floral wire through the center of the I-cord.

# peperomia

(PAPER, LAYER)

*Peperomia, while less widely grown as houseplants than some others, are a great choice for a desk or dish garden, as they take up very little space, and actually grow fairly well under fluorescent lights. Don't overwater them, and they'll do just fine.*

## MATERIALS

o Green paper

o Yellow paint marker or colored pencil

o Scissors or X-Acto

o Hot glue

o Wire

## SIZE

*Length: 5½ inches/14 cm*

*Width: 5½ inches/14 cm*

*Height: 10 inches/25.4 cm*

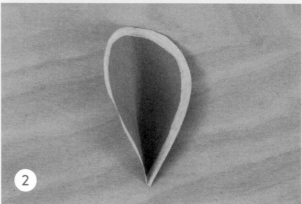

### 1) Cut

Take a piece of green paper and cut out a symmetrical leaf that is rounded at the top and pointed at the bottom. This project requires multiple leaves (around 20) to create volume.

### 2) Draw

Use a yellow paint marker or colored pencil to line the outer edge of the leaves with some detail.

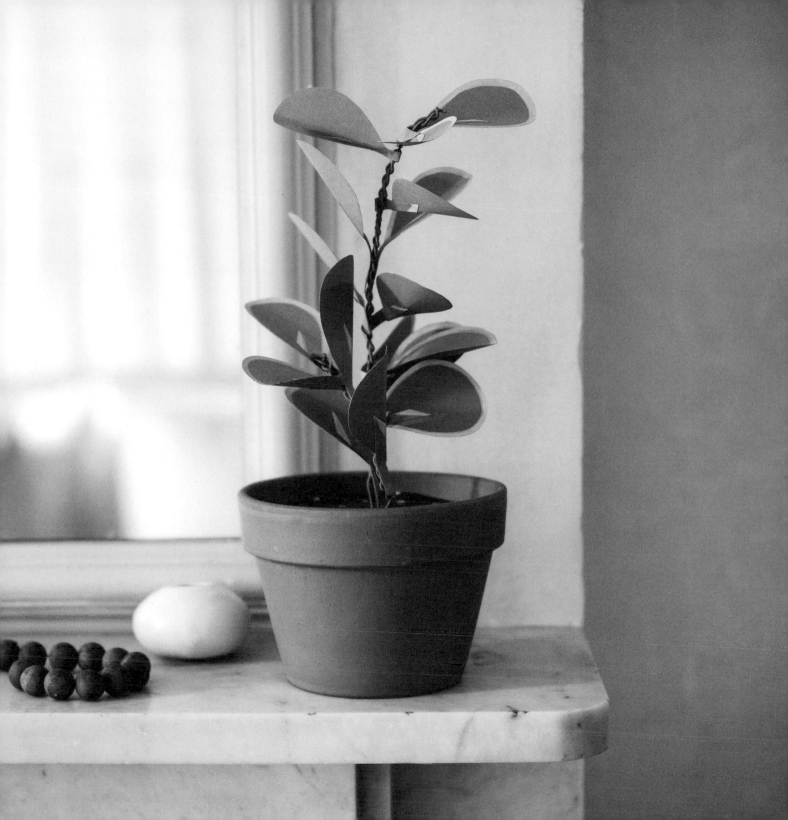

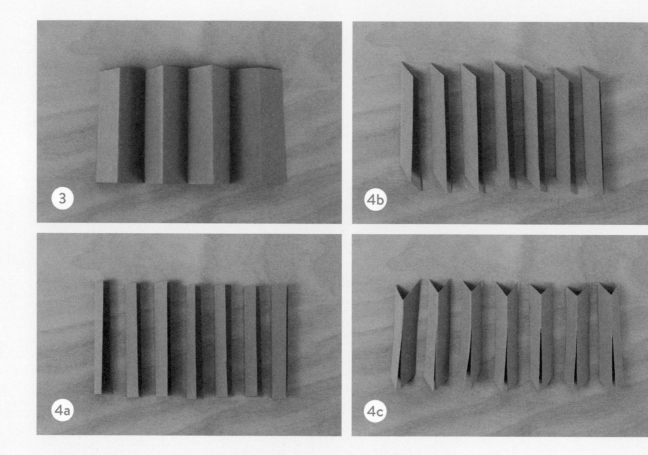

### 3) Fold

To make small stems for these leaves so that they can attach onto the larger wire stems, make an accordion fold out of a second piece of green paper (see page 47 for instructions on accordion folds).

### 4) Cut

Cut the planes in half so that you are left with multiple singular corners. These long pieces can be cut at an angle on both ends and sliced toward the center crease. You can draw more yellow detail on the stem to mimic a peperomia leaf once it is attached.

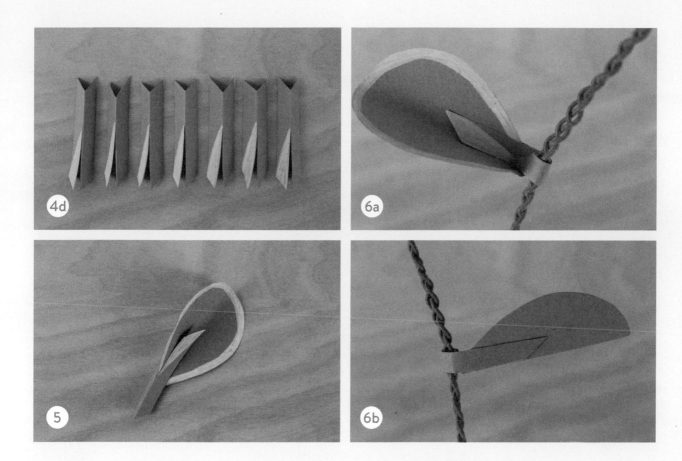

## 5) Adhere

Add a small amount of glue to the paper stem and slide it into the bottom (pointed area) of the leaf you cut out earlier. Repeat this step for all of the leaves.

## 6) Attach

Cut three 10 to 15-inch/25 to 38 cm lengths of floral wire and braid them together. Wrap the end of the small paper stem around the wire stem with hot glue and press until it dries. Apply every leaf this way until you have a full peperomia plant.

## Finish

Stick the wire stems in a piece of cardboard or Styrofoam that fits inside your planter and cover it with brown paper to mimic soil.

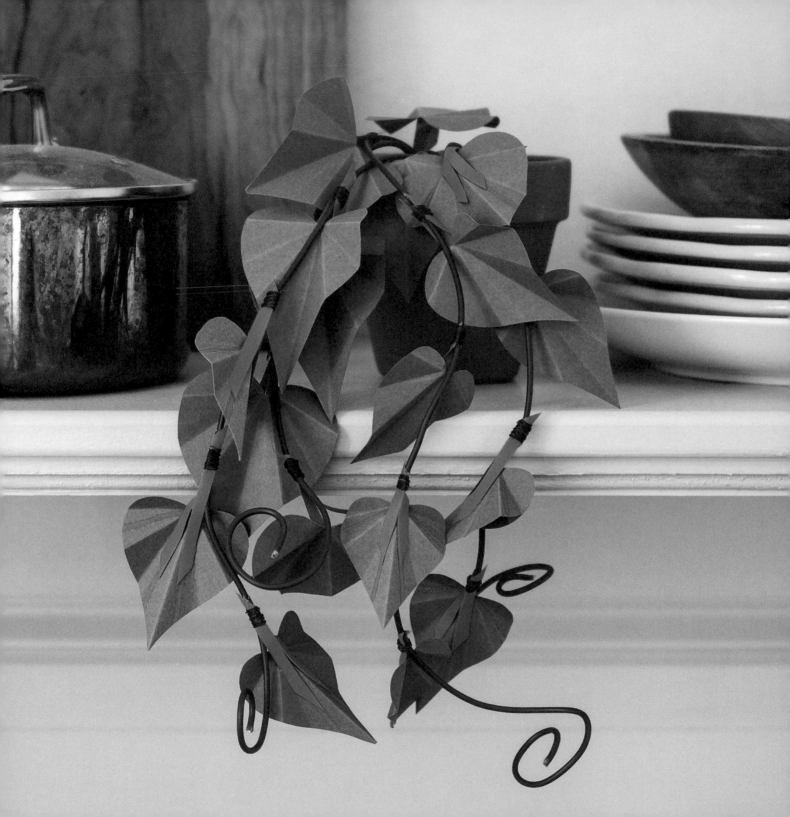

# philodendron

## (PAPER, FOLD)

*The name "philodendron" derives from Greek, and translates to "love tree." They have unusually large and impressive leaves, and their flowers have a spathe and a spadix, like an anthurium or a calla lily. Some philodendrons have nectar-producing glands found outside of the flowers, attracting ants who do no harm to the plant, but in fact protect it from other insects that might want to eat it.*

## MATERIALS

○ Green paper

○ Orange paper

○ Orangish-red pencil

○ Scissors or X-Acto

○ Hot glue

○ Thick floral wire

## SIZE

*Length: 14 inches/35.6 cm*

*Width: 3 inches/7.6 cm*

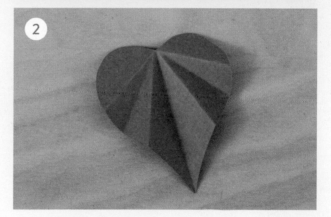

### 1) Cut

Fold a piece of approximately 3 × 3-inch/7.5 × 7.5 cm green paper in half to cut out a symmetrical leaf that resembles a heart. This project requires multiple leaves (around 20 that can range in size) to create volume.

### 2) Fold

Make symmetrical folds radiating from the top center with peaks facing down and up in a fashion similar to the accordion fold.

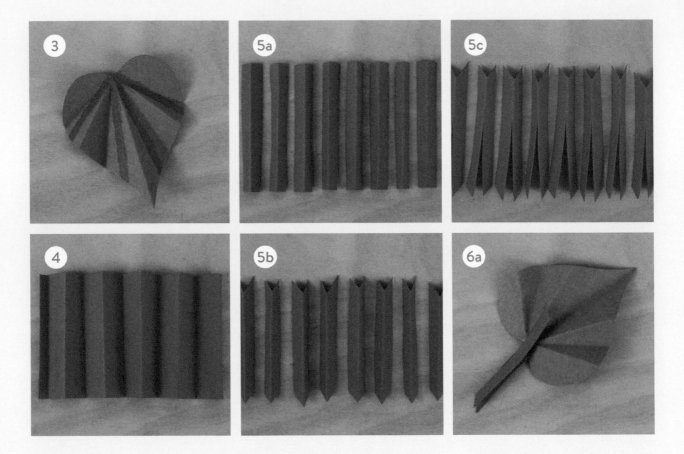

### 3) Draw

Use an orangish-red colored pencil to embellish the bottom of each leaf. Only draw on a few of its planes to mimic a heartleaf philodendron plant.

### 4) Fold

Make an accordion fold out of the 7 × 4-inch/18 × 10 cm orange paper (see page 47 for instructions on accordion folds). Make as many stems as you have leaves.

### 5) Cut

Then cut the planes in half so that you are left with multiple singular corners. These long pieces can be cut at an angle on both ends and sliced toward the center crease.

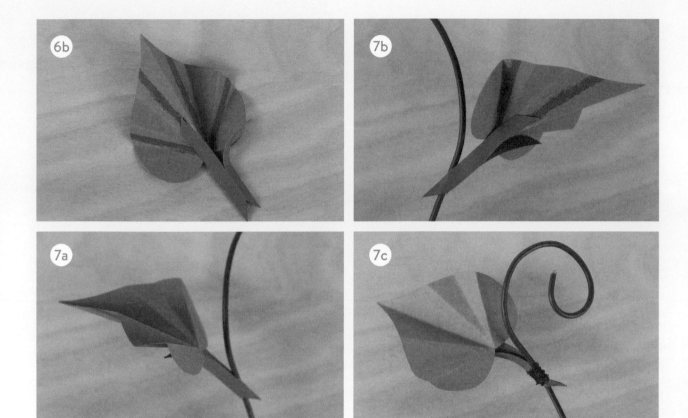

## 6) Adhere

Add a small amount of glue to the paper stem and slide it into the bottom (rounded area) of the leaf you cut out earlier. Repeat this step for all of the leaves. You might want to curl one part of the stem to mimic the growth of a new leaf.

## 7) Attach

Cut a 12 to 17-inch/30 to 43 cm length of wire. Wrap the end of the small paper stem around the wire stem, dabbing with hot glue. Press in place until it dries. This wire is flexible and can be curved as it hangs. Apply every leaf this way until you have a full cascading philodendron plant. Wrap floral wire around the attached stems to provide added support.

**Finish**

Stick the wire stems in a piece of cardboard or Styrofoam that fits inside your planter and cover it with brown paper to mimic soil.

# zz plant

### (PAPER, LAYER)

*Zamioculcas zamiifolia, the ZZ plant, Zuzu plant, or Zanzibar Gem, has an unusual ability to filter air, more so than other plants. It removes volatile organic compounds from the air, making it an ideal houseplant. It's mildly toxic, with needle-like calcium oxalate crystals that can cause irritation, but it has been used as a traditional medicine in parts of the world, as well.*

## MATERIALS

○ Green paper

○ Scissors or X-Acto

○ Hot glue

○ Small tree branches

○ Green acrylic paint

## SIZE

Width: 9½ inches/24.1 cm

Height: 21 inches/53.3 cm

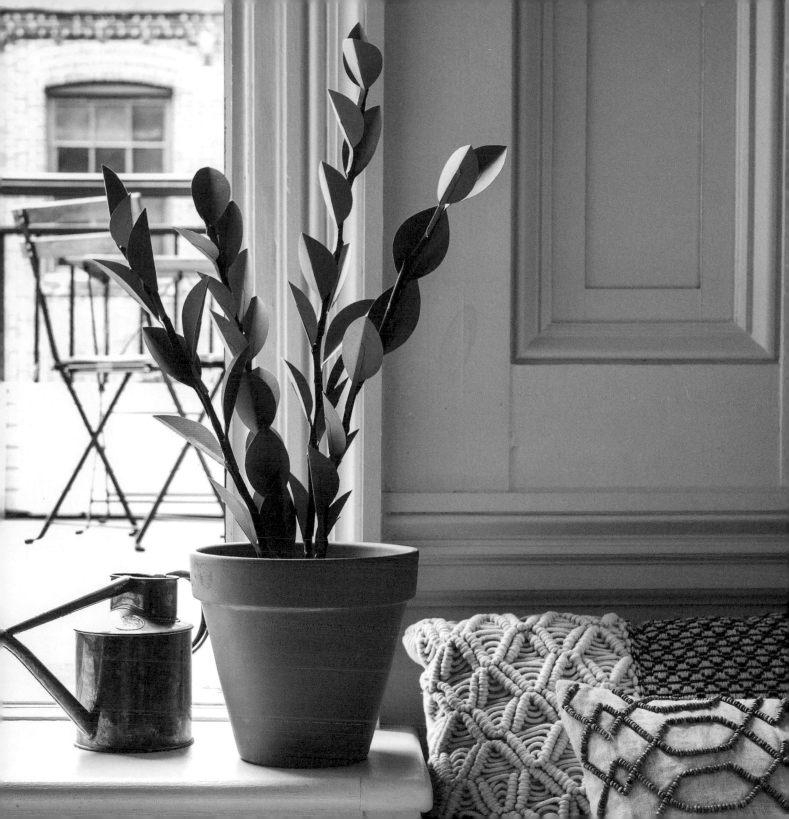

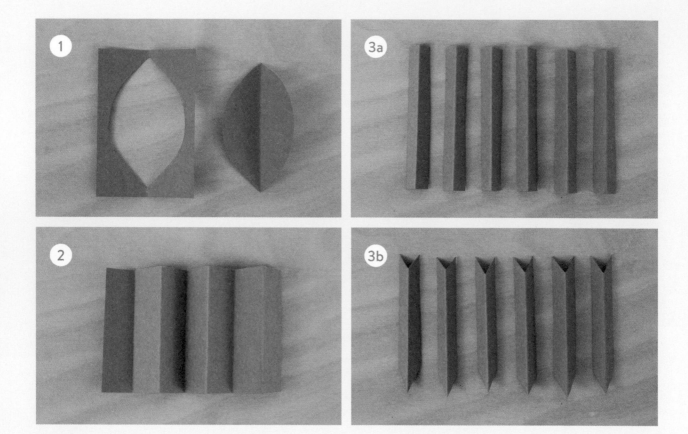

1) **Cut**

Take a piece of green paper and fold it in half to cut out a symmetrical leaf that has tapered points at both the top and bottom. This project requires multiple leaves (around 20) to create volume.

2) **Fold**

Make an accordion fold out of a 7 × 4 inch/18 × 10 cm piece of green paper (see page 47 for instructions on accordion folds). Make as many stems as you have leaves.

3) **Cut**

Cut the planes in half so that you are left with multiple singular corners. These long pieces can be cut at an angle on both ends and sliced toward the center crease.

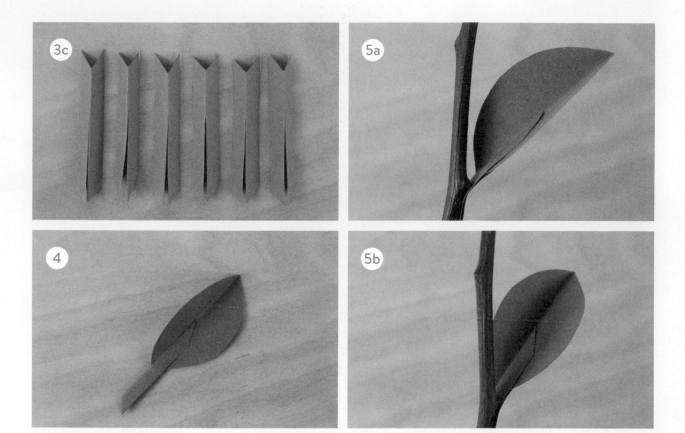

## 4) Adhere

Add a small amount of glue to the small paper stem and slide it into the crease of the leaves you cut out earlier. Repeat this step for all of the leaves.

### Paint

Find a few fallen tree branches and paint them green. The ZZ plant has thick stalks that cannot be replicated with thin wire.

## 5) Attach

Open the end of the small paper stem and apply hot glue. Press it onto the tree branches until it dries. Apply every leaf this way and in a 50/50 offset pattern to mimic the orderly look of the ZZ.

### Finish

Stick the thick stems in a piece of cardboard or styrofoam that fits inside your planter and cover it with brown paper to mimic soil.

# bonsai tree

(WOOL, NEEDLE FELT)

Bonsai is the ancient Japanese art of growing trees in small containers. They can be created using any woody tree or shrub species, but the most popular ones have small leaves or needles, in keeping with a bonsai's compact nature. Although each bonsai is an individual work of art, there are certain traditionally accepted styles, including formal upright (chokkan), which looks like a very small conifer; informal upright (moyogi), which is less symmetrical; cascade (kengai), which looks a bit like a tree leaning over a waterfall; and slant (shakan), which is shown here.

## MATERIALS

- Small container
- Rock that fits comfortably in the container
- One thick sheet of brown felt suitable for needle felting
- Scissors
- Felting needle
- Wine cork
- Jewelry or floral wire, minimum 22 gauge
- Glue gun
- 1 oz brown wool roving
- ½ oz dark-green wool roving
- ½ oz light-green wool roving

## SIZE

*Length: 5 inches/12.7 cm*

*Width: 3 inches/7.6 cm*

*Height: 11½ inches/29.2 cm*

## Pattern

Cut a piece of felt large enough to cover your rock. Needle felt it in place, tuck the rock into the pot and arrange some more felt around it to form a kind of hill, again needle felting it in place.

Hot glue the cork onto the rock to form the base of the trunk. Twist the wire to form the branches, using hot glue to anchor it to the trunk, and to stabilize the branches as needed. There is no need to be artistic or neat here—it's all going to be covered anyway. Just go for stability, and be creative and have fun with it!

Wrap brown roving around the trunk and branches and needle felt it in place.

Take a small piece of dark-green roving and roll it between your palms until it forms a relatively stiff ball, moistening your palms if necessary. Make several of these—around 30 or so, depending on how you designed your branches. Needle felt the balls onto the branches.

Make 12 or 15 balls of roving out of the lighter green, again as needed depending on how you designed your branches. Needle felt these balls in among the darker-green balls, to provide some contrast.

Spread small, relatively thin pieces of light-green roving over the brown felt at the base of your bonsai tree, and needle felt them in place to form the grass.

Check over your tree for any loose felt or thin layers, addressing those issues as you come across them.

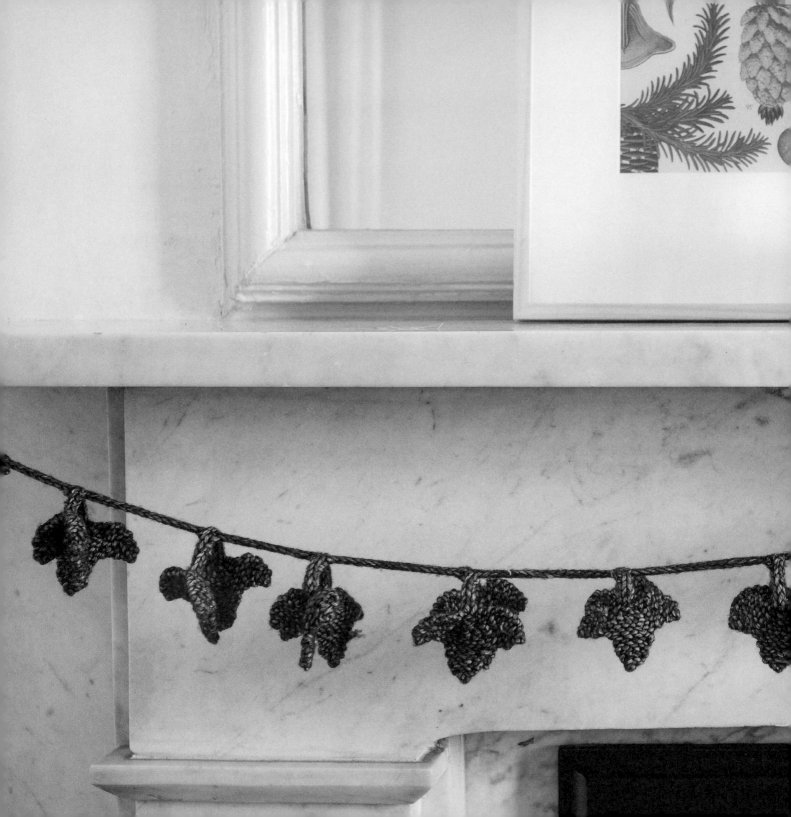

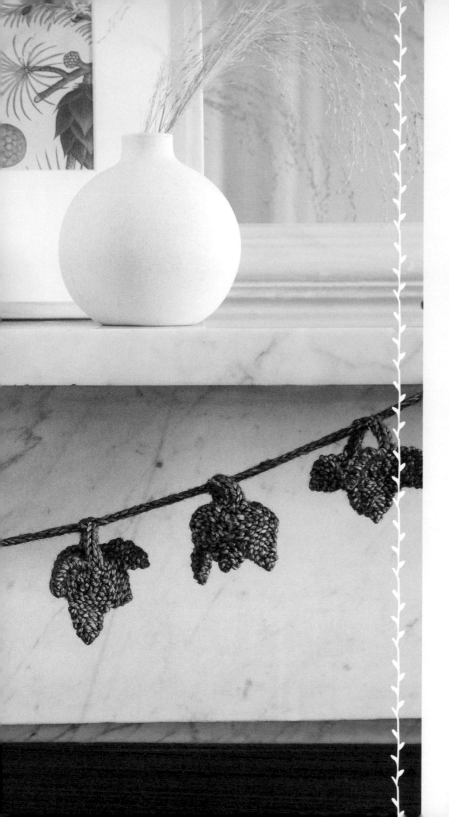

# climbing ivy

## (WOOL, KNIT)

*Ivy, also called Hedera, is an evergreen, woody vine. If left on the ground, it will only grow about five inches high, but if it can find something to climb up it will grow 90 feet high or more. Ivy is invasive, and can damage its host if it is allowed to climb on trees. On the other hand, it looks quite fetching on brick buildings or trellises.*

## MATERIALS

- US 2/2.75 mm set of 4 double-pointed needles

- 220 yards/201 meters worsted weight yarn (shown in Malabrigo Rios, in color Fresco y Seco)

- Tapestry needle

- Scissors

## SIZE

*Length: 61 inches/155 cm*

*Width: 4 inches/10.2 cm*

### Leaves (make 54, or any multiple of 2)

Cast on 3 sts, leaving a 6-inch/15 cm tail. Work an I-cord as follows:

**Row 1:**
K3, but do not turn, slide back to right end of the needle.

**Row 2:**
Bring yarn across back of the needle, pull it tight, k3 but do not turn.

Repeat the last row until the I-cord is 1 inch/2 cm long. Turn at end of last row.

Continue leaf as follows:

**Row 1 and all unspecified odd rows:**
Knit.

**Row 2 (inc):**
(K1, m1) twice, k1—5 sts.

**Row 4 (inc):**
(K1, m1) 4 times, k1—9 sts.

**Row 6 (inc):**
(K1, m1) 8 times, k1—17 sts.

**Row 8:**
Knit.

**Row 10:**
K5, (k2, lift first st over second st and off needle to bind off 1 st, knit 4 more sts) twice—15 sts remain, with 5 sts on each of 3 lobes.

### Left Lobe

**Row 11:**
K5, turn, leaving remaining sts unworked.

**Row 12:**
K1, sl 1, k2tog, psso, k1—3 sts remain for left lobe.

**Row 13:**
Knit.

**Row 14:**
Sl 1, k2tog, psso—1 st remains for left lobe. Break yarn and fasten off remaining st.

### Center Lobe

Rejoin yarn to center 5 sts.

**Rows 15–19:**
K5, turn leaving remaining sts unworked.'

**Rows 20–22:**
Repeat rows 12–14—1 st remains. Break yarn and fasten off remaining st.

### Right Lobe

Rejoin yarn to remaining 5 sts.

**Rows 23–26:**
Repeat rows 11–14—1 st remains. Break yarn and fasten off remaining st.

Weave in ends at the tips of the leaf, leaving the cast-on tail for joining leaf to vine.

### Vine

Cast on 3 sts. Work as I-cord for 55 inches/140 cm, or desired length. Break yarn and fasten off sts. Weave in ends.

### Finishing

Using tails from each leaf threaded in tapestry needle, sew them to the vine, grouping 2 leaves together every 2 inches/5 cm, and grouping 3 leaves at each end of the vine.

Weave in remaining ends.

# ABBREVIATIONS LIST for KNIT and CROCHET PROJECTS

| | | | | |
|---|---|---|---|---|
| **CC** | contrast color | | **mm** | millimeter(s) |
| **ch** | chain | | **p** | purl |
| **ch-sp(s)** | chain space(s) | | **p2tog** | purl two together |
| **cm** | centimeter(s) | | **pm** | place marker |
| **dc** | double crochet | | **psso** | pass slipped stitch over |
| **dec** | decrease | | **rnd(s)** | round(s) |
| **dpn** | double-pointed needle | | **sc** | single crochet |
| **hdc** | half double crochet | | **sc2tog** | single crochet two together |
| **inc** | increase | | **sc3tog** | single crochet three together |
| **k** | knit | | **sl** | slip |
| **k1tbl** | knit one through the back loop | | **sl st** | slip stitch |
| **k2tog** | knit two together | | **ssk** | slip, slip, knit |
| **kf&b** | knit in front and back of same stitch | | **st(s)** | stitch(es) |
| | | | **yo** | yarn over |
| **M1** | make 1 | | | |
| **MC** | main color | | | |

# STITCH DICTIONARY

**CHAIN** — Draw a loop through the loop on your hook.

**DOUBLE CROCHET** — Yarn over (2 loops on hook). Insert hook into the next stitch, yarn over, draw yarn through the stitch (3 loops on hook). Yarn over, draw yarn through the first two loops on hook (2 loops on hook). Yarn over, draw yarn through the remaining loops on hook (1 loop on hook).

**HALF DOUBLE CROCHET** — Yarn over (2 loops on hook). Insert hook into the next stitch, yarn over, draw yarn through the stitch (3 loops on hook). Yarn over, draw yarn through all three loops on hook (1 loop on hook).

**KNIT** — Insert right needle into stitch on left needle upward from front to back. Yarn over, pull the yarn down and through the stitch on the left needle, creating a new stitch. Lift this new stitch off the left needle and onto the right.

**KNIT FRONT AND BACK** — Knit into the front and then the back of the same stitch, to increase stitch count by 1.

**KNIT THROUGH THE BACK LOOP** — Knit into the back of the stitch, behind the needle.

**KNIT TWO TOGETHER** — Insert right needle into the first 2 stitches on left needle upward from front to back. Yarn over, pull the yarn down and through both stitches on the left needle, creating a new stitch. Lift this new stitch off the left needle and onto the right. 1 stitch decreased.

**MAKE 1** — Using your left needle, pick up the bar between the stitch on your left needle and the stitch on your right needle. Knit into the back of this created stitch. 1 stitch increased.

**PLACE MARKER** — Place a stitch marker on your right needle.

**PURL** — Insert right needle into stitch on left needle downward from back to front. Yarn over, and pull the yarn up and through, creating a new stitch. Lift this new stitch off the left needle and onto the right.

**PURL TWO TOGETHER** — Insert right needle into the first 2 stitches on the left needle downward from back to front. Yarn over, pull the yarn up and through both stitches on the left needle, creating a new stitch. Lift this new stitch off the left needle and onto the right. 1 stitch decreased.

**SINGLE CROCHET** — Insert hook into the next stitch. Yarn over, draw yarn through the stitch (2 loops on hook). Yarn over, draw yarn through both loops on hook (1 loop on hook).

**SINGLE CROCHET TWO TOGETHER** — Insert hook into next stitch. Yarn over, draw yarn through the stitch (2 loops on hook). Insert hook into next stitch. Yarn over, draw yarn through the stitch (3 loops on hook). Yarn over, draw yarn through all loops on hook (1 loop on hook). 1 stitch decreased.

**SINGLE CROCHET THREE TOGETHER** — Insert hook into next stitch. Yarn over, draw yarn through the stitch (2 loops on hook). Insert hook into next stitch. Yarn over, draw yarn through the stitch (3 loops on hook). Insert hook into next stitch. Yarn over, draw yarn through the stitch (4 loops on hook). Yarn over, draw yarn through all loops on hook (1 loop on hook). 2 stitches decreased.

**SLIP, SLIP, KNIT** — Slip next 2 stitches knitwise. Slip tip of left needle into the front of the slipped stitches, and knit them together. 1 stitch decreased.

**SLIP STITCH** — Insert hook into next stitch. Yarn over, draw yarn through both loops on hook.

**YARN OVER** — Wrap yarn around hook or needle.

# INDEX

# ACKNOWLEDGMENTS

Thank you to Therese Chynoweth and her sharp eyes, to Steve Legato for his stunning photographs, to Kristi Hunter for her amazing prop styling, to Kristin Kiser for keeping me happily busy, to Susan Van Horn for making everything beautiful, and most of all to Shannon Connors Fabricant for always loving all the pretty.

Thank you to Anna Noyes without whom this book probably wouldn't have existed. I miss you, friend.

Thank you to Kelly Notaras, Chandika Devi, and Rachel Mehl. You ladies rock my world.

Thank you Dave for never complaining about all the wool, and thank you Maile for all your help with this one.

Thank you to my sister, even though she didn't like any of my stuff. And finally, thank you to my mom, for breezily saying, "*The No-Kill Garden*? Never heard of it."

— *Nikki Van De Car*

Thank you to my family. To Mom, Mom Rio, for passing your art supplies down to me when you passed on. To Aunt Lisa, Aunt Teresa, Dad, and Mom for your lifelong encouragement.

Thank you to my main high-spirited motivator, Andrew Jeffrey Wright, for walking among piles of cut paper for months.

Thanks to Nate Harris for being the delivery driver under pressure and Dave Bradburn for the insider look at plant life.

Thank you Bridget Duvic, Laura Weiszer, Sydney Hernandez, Mike V., Steph Gonzalez, Ryan Greenberg, and Joseph Amsel for your positive interest and distractions.

Lastly, to the gracious Jameela Wahlgren, thank you for introducing me to the inspiring Shannon Connors Fabricant, Susan Van Horn, and Nikki Van De Car.

— *Angela Rio*